POSTCARD HISTORY SERIES

Missoula

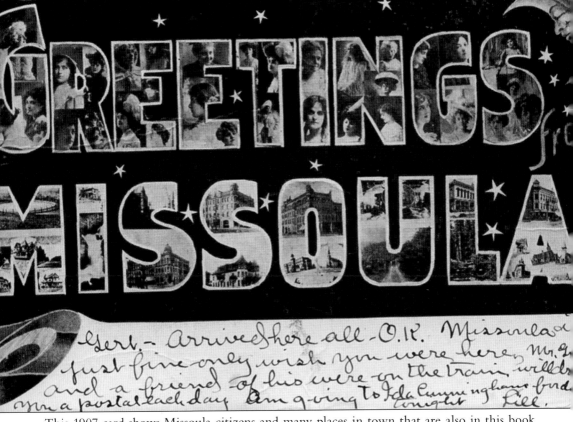

This 1907 card shows Missoula citizens and many places in town that are also in this book. This card was sent to Butte, Montana, and was delivered by train as indicated by the stamp on the back that says, "Train late, mail delayed." (Robert A. Svoboda Collection.)

On the Front Cover: This is a pre-1910 view of North Higgins Avenue looking south with the Higgins Avenue Bridge in the distance. Although there is an awning shown on the extreme left that says automobile garage, all the vehicles on the avenue are horse-drawn. The intersecting street in the middle is Cedar Street, now Broadway. (Robert A. Svoboda Collection.)

On the Back Cover: This parade down Higgins Avenue was in celebration of the Missoula Stampede that was held in 1915 at the present Missoula County Fairgrounds. This event was held around the Fourth of July holiday in 1915, 1916, 1917, and 1918. A rodeo was one of the main events at each stampede. (Robert A. Svoboda Collection.)

POSTCARD HISTORY SERIES

Missoula

Stan B. Cohen and the
Svoboda Collection at the Northern Rockies Heritage Center

ARCADIA
PUBLISHING

ISBN 978-0-7385-5888-2

Published by Arcadia Publishing
Charleston SC, Chicago IL, Portsmouth NH, San Francisco CA

Printed in the United States of America

Library of Congress Catalog Card Number: 2008928325

For all general information contact Arcadia Publishing at:
Telephone 843-853-2070
Fax 843-853-0044
E-mail sales@arcadiapublishing.com
For customer service and orders:
Toll-Free 1-888-313-2665

Visit us on the Internet at www.arcadiapublishing.com

*To all the early and modern-day photographers
who have and are chronicling the history of Missoula*

CONTENTS

ACKNOWLEDGMENTS

This book would not have been possible without the generous donation of over 22,000 Montana postcards collected by Robert A. Svoboda and his mother over a 90-year period. They were donated to the Northern Rockies Heritage Center, the nonprofit steward of a large part of the remaining historic structures at Fort Missoula. Over 1,000 of these cards are of Missoula and the surrounding area.

In the past 32 years, I have published many of Missoula's history books and hundreds of local people have provided postcards, photographs, and historical information to me from which I have written the captions for this postcard book.

In addition, through the years, I have received much help to portray the history of our area through visual means from the Montana Historical Society, the K. Ross Toole Archives at the University of Montana, and the Historical Museum at Fort Missoula. Much material in the form of newspaper articles has been gleamed from the files of the *Missoulian*, the *Missoula Sentinel*, and other local newspapers.

My good friend Frank Houde, who we lost in 2007, and Tom Mulvaney, Montana's premier postcard collector and dealer, were and are a great help.

Missoula was lucky to have a number of local photographers who produced postcards through the years. The most prolific was R. H. McKay, who was in business from 1908 to 1946 and left a large legacy of views, a number of which are used in this book. Robert Catlin was another major area photographer and postcard producer.

Finally I received encouragement and help from Jim Azzara, executive director of the Northern Rockies Heritage Center, and Tate Jones, board president. Thanks also to Hannah Carney of Arcadia Publishing for her guidance and to local historians Allan Mathews, and Philip Maechling, Missoula's historic preservation officer, for reviewing the historical data.

All cards in this book are from the Robert A. Svoboda Collection.

INTRODUCTION

Missoula, known as "The Garden City," is the oldest large city in Montana, with its nonnative history dating back to the Lewis and Clark expedition in 1805–1806, to the Jesuits' priests in the 1840s in the surrounding area, and to the beginnings of a trading post in 1860. Native American tribes, mainly Salish-Kootenai, Pend d'Oreille, Nez Percés, and occasionally Blackfeet, used a trail through a narrow canyon to the east named Porte d'Enfer or "Hell's Gate" to travel to and through the large Missoula Valley.

In 1860, the two founding fathers of Missoula, Christopher P. Higgins and Francis L. Worden, opened a trading post at Hellgate Village, west of present downtown on the Mullan Military Road. The road, constructed from 1858 to 1863, connected Fort Benton, Montana, at the end of navigation on the Missouri River with Fort Walla Walla in the Washington Territory.

The trading post served settlers, miners, and Native Americans for a few years. The need for water power necessitated a move in 1864–1865 to what is now downtown Missoula, west of a flume from Rattlesnake Creek to what would become Higgins Avenue. The flume provided power for a gristmill and a sawmill. By the late 1870s, with the establishment of Fort Missoula south of town and the construction of buildings and homes in the soon-to-be downtown area, Missoula was starting to establish permanent roots.

The completion of the Northern Pacific Railroad (NP) into Missoula in 1883 gave the town the spark to expand by opening corridors of transportation east and west. The Chicago, Milwaukee, and St. Paul Railroad (the Milwaukee Road) came in 1908 and increased the development of the south side of town.

In 1893, Missoula became the center of educational opportunities when the town was selected as the site for the University of Montana. By this time, the economy was heavily dependent on the timber business, with sawmills in town and a huge facility at Bonner.

Fort Missoula was established in 1877 after a request from local citizens for protection from Nez Perce' Indians, and it has served as a military post ever since. The post was a site for an alien detention camp and a U.S. Army prison during and after World War II. Today the fort has been parceled out to various private and government organizations: the privately owned Community Hospital complex, Bureau of Land Management, U.S. Forest Service, the Northern Rockies Heritage Center, and two museums. In addition, a large amount of the land has been converted to recreational use.

The U.S. Forest Service established its first national regional office in Missoula in 1906, covering at the time Montana, northern Idaho, and eastern Washington. In 1910, the great

forest fire that swept along the Montana-Idaho divide occurred, and Missoula provided a safe haven for hundreds of refuges from the west.

Missoula's other major natural disaster was the June 1908 Missoula (now Clark Fork) River flood. It washed out train tracks and houses, flooded part of the downtown area, and dropped the center span of the Higgins Avenue Bridge, disrupting traffic flow from the downtown area to the southside.

The Western Montana Fair, established in 1879, is one of the oldest fairs in Montana. It moved to its present location in 1915, and one of the original buildings is still in use. A major fire in 1941 closed the fair, and it did not open again until 1954. Adjacent to the fairgrounds was Missoula's first airport, Hale Field, which opened in 1927. It was the home of the mountain flying pioneer company, Johnson Flying Service, until the field closed in 1954. All flying operations were moved to the present airport, west of town, which was a Works Progress Administration (WPA) project in the early 1940s. The country's largest aerial firefighting company, Neptune Aviation, is located at the airport along with the U.S. Forest Service aerial fire depot and other research facilities.

Recreational and cultural resources abound in western Montana. A professional Pioneer League baseball team plays in the new stadium in the Southside area—a legacy of the old Timberjacks team from the 1950s. The Montana Children's Theater, now housed in the old Central School building, has an international reputation. The historic Wilma Theater downtown is being restored to its mid-century glory and promotes many film festivals.

There are nine National Register of Historic Places districts in the city, and the city/county Historic Preservation Office is one of the most active in the state. Preserve Historic Missoula has been established to take a proactive stand on saving historic sites and recently helped save the historic Lincoln School in the Rattlesnake area.

Today Missoula is the second largest city in the state, and though the timber industry has been considerably reduced, the economy is now trade, government, educational, medical, and recreation oriented.

The Robert A. Svoboda Collection, started by his mother in the early 1900s, had more than 22,500 postcards by the time he donated the collection to the Northern Rockies Heritage Center. The collection covers the entire state of Montana. Svoboda was born in Lewistown, Montana, and served in the U.S. Navy in World War II. Graduating from the University of Montana in 1949, he spent his career in business and retired as CEO and chairman of the board of a large California bank in 1991. Svoboda lives in California and Hawaii.

Through the years, he became a prolific collector of Montana items—from tokens to books and paper items, especially postcards. The Svoboda collection has provided a visual look at Missoula for more than 100 years, and the author has tried to present as many diverse images as possible.

One

EARLY-1900S VIEWS

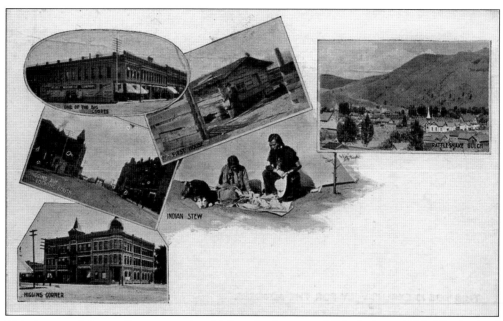

This is one of the earliest postcards of Missoula. It was published about 1899. The back of the card is marked, "Private Mailing Card." The U.S. Post Office would not allow the word "private" printed on postcards after 1901. The card shows, from top left to right, the Missoula Mercantile building, Missoula founder Francis Worden in front of his store at old Hellgate Village, and a pre-1900 view of the lower Rattlesnake area; (second row) Higgins Avenue looking south, and Native Americans cooking stew. The Higgins Block was built in 1889.

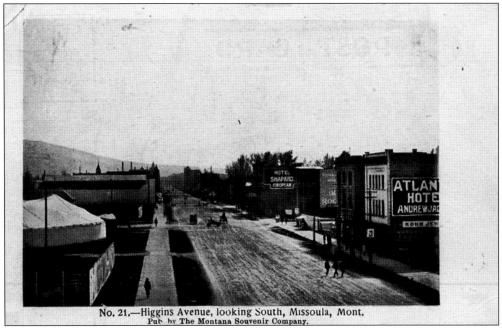

No. 21.—Higgins Avenue, looking South, Missoula, Mont.
Pub by The Montana Souvenir Company.

This view of Higgins Avenue looking south is one of the oldest postcards showing Missoula's main street. The Atlantic Hotel building is still standing, the Hotel Shapard burned down in 1942, and the tent sits on the site of the present Circle Square building, former home of the *Missoulian*.

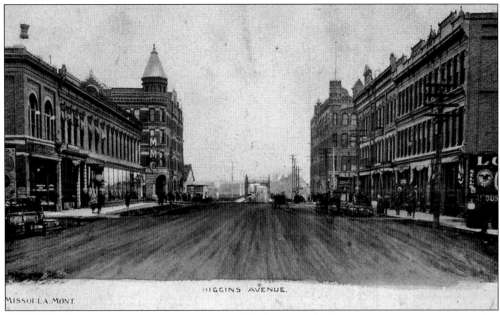

HIGGINS AVENUE.

MISSOULA, MONT.

In another very early view of Higgins Avenue looking south, the 1890 Higgins Avenue Bridge crosses the Missoula (now Clark Fork) River and the small hip-roofed building to the far left is the original 1864 Missoula mill, which was torn down in 1912. Other buildings on the left are the First National Bank and the Missoula Mercantile Company. On the right are the Hammond Building and the Florence Hotel.

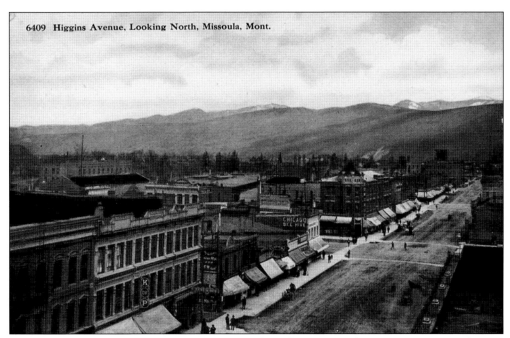

6409 Higgins Avenue, Looking North, Missoula, Mont.

This 1911 view of Higgins Avenue looks north at the corner of Higgins Avenue and Main Street. The large building at the intersection is the Daly Block. Higgins Avenue would be paved with bricks the next year.

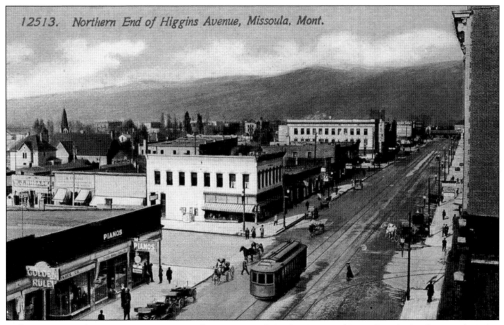

12513. Northern End of Higgins Avenue, Missoula, Mont.

A later view of Higgins Avenue, at the corner of Cedar Street (Broadway), looks north. The white building in the center was the home of Smith Drug for many years. Notice the number of horse-drawn vehicles and the vintage cars, which would date this card to about 1912–1915. The Golden Rule store in the left corner was familiar to towns throughout the West at this time.

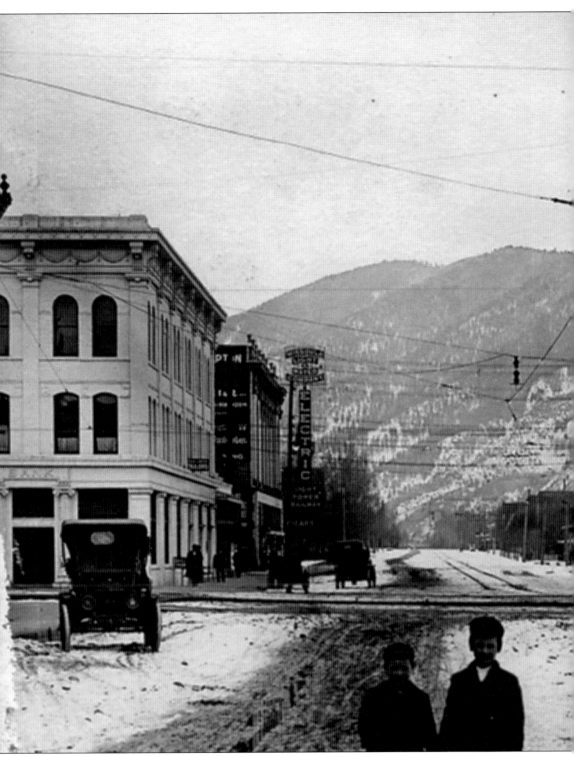

A great view of Cedar Street (now Broadway) looks east about 1910–1911. The Montana Building is on the right; the Gibson Block is on the left. Many lawyers had their offices

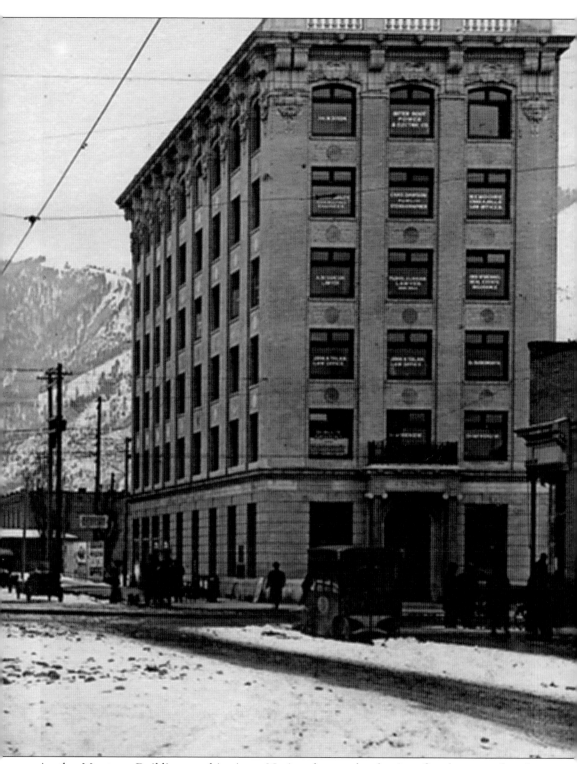

in the Montana Building at this time. Notice the overhead wires for the new electric streetcar service.

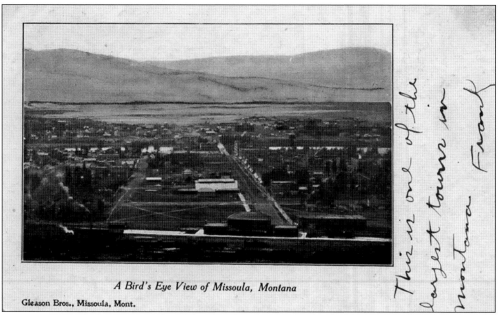

A Bird's Eye View of Missoula, Montana

Gleason Bros., Missoula, Mont.

Missoula in 1907 was, as the message says, one of the largest towns in Montana but far behind Butte, the largest city in the state. The southside was basically empty, and the area close to the NP depot at the end of Higgins Avenue had not filled in yet.

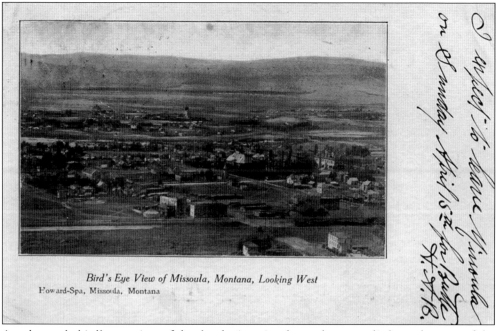

Bird's Eye View of Missoula, Montana, Looking West

Howard-Spa, Missoula, Montana

Another early bird's-eye view of the developing city shows the area a little to the west of the main downtown area, including the St. Francis Xavier Catholic Church, Sacred Heart Academy, some new hotel buildings, and, in the distant center, the flour mill on South Third Street.

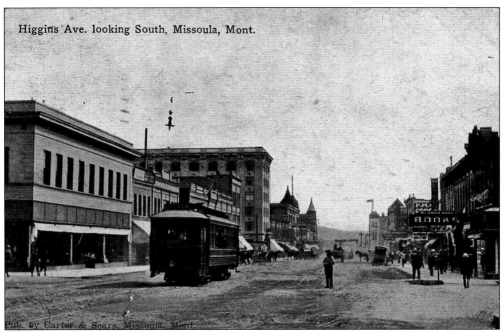

This postcard is of a busy day on Higgins Avenue in 1912, looking south. The large building on the left is the Lucy Furniture store, built in 1909, with the six-story Montana Building farther down the street. This card was printed before the street was bricked. Electric streetcars replaced horse-drawn cars in 1910.

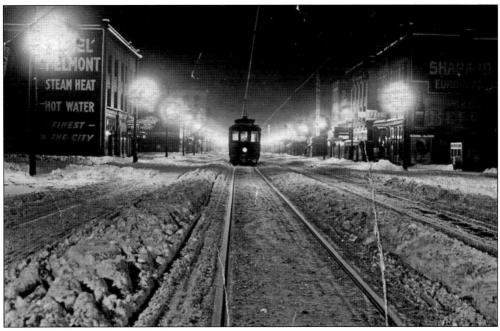

This interesting night snow scene took place on North Higgins Avenue in 1913. The Hotel Belmont building is still standing. At one time, Missoula claimed that Higgins Avenue was the best-lighted street in America.

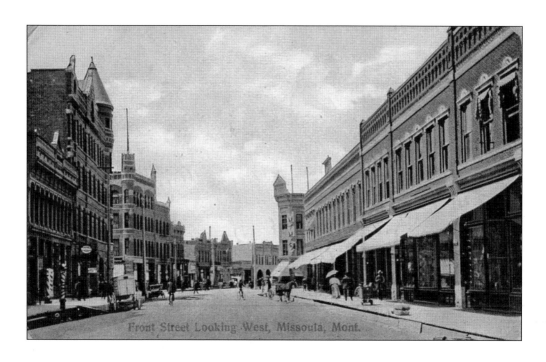

Front Street Looking West, Missoula, Mont.

Here are two 1915 views of Front Street, which was the route through town for the 1860s Mullan Military Road. The top view looks west with the Missoula Mercantile store on the right, then the Florence Hotel. On the left are the First National Bank building and the Hammond Building. In the distance can be seen a building with archways, which was the Star Garage. The bottom view looks east. The Hammond Building and the First National Bank are on the right, and the Florence Hotel is on the left.

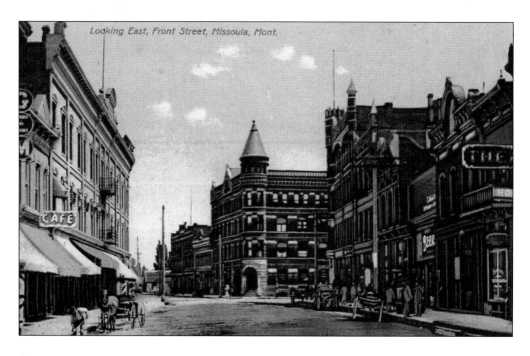

Looking East, Front Street, Missoula, Mont.

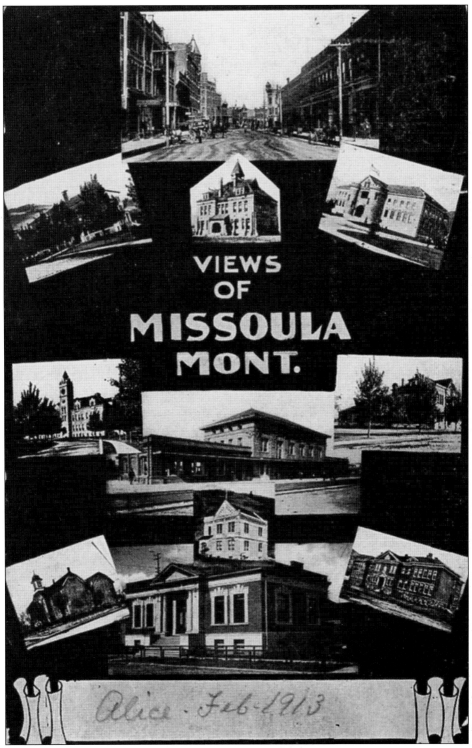

VIEWS
OF
MISSOULA
MONT.

Alice - Feb. 1913

By 1913, Missoula had some impressive buildings, including schools and the University of Montana campus (top view).

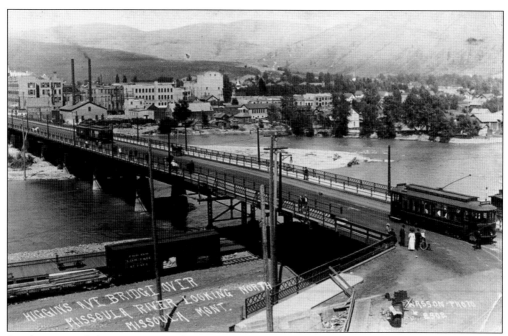

By the time of this 1910 view, the Higgins Avenue Bridge had been rebuilt after the 1908 flood, with streetcar tracks and the new Milwaukee Road (Chicago, Milwaukee, and St. Paul) tracks running underneath. The power plant can be seen at the north end of the bridge and right behind it is the original 1864 mill. A new bridge with a river course change was built in 1962.

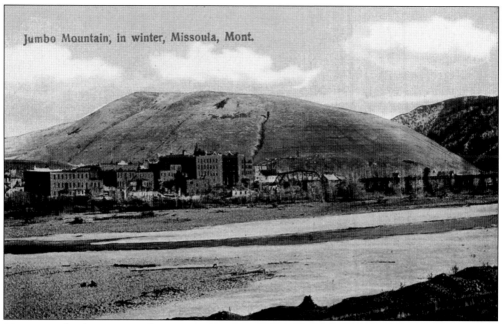

Jumbo Mountain, in winter, Missoula, Mont.

Mount Jumbo looms over the downtown area in this view taken before 1908 as the original Higgins Avenue Bridge is still in use. The river at this time was called the Missoula River.

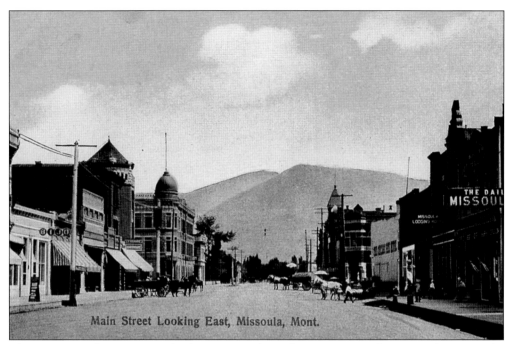

Main Street Looking East, Missoula, Mont.

This is a view of Main Street, looking east in the early 1900s. Note the Bijou Theater on the left along with the large Daly Block, home to the D. J. Hennessy Company. Across the street is the Higgins Block, and on the opposite corner is the Union Block, home of the Western Montana National Bank. The Chicago Bee Hive store and the *Daily Missoulian* office are on the right.

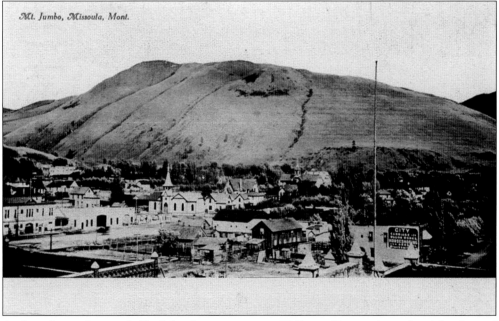

Mt. Jumbo, Missoula, Mont.

A view shows the east half of the downtown area. Hellgate Canyon is to the right. Several churches and Central School were located in this area. The top of the Missoula Mercantile is at the bottom left.

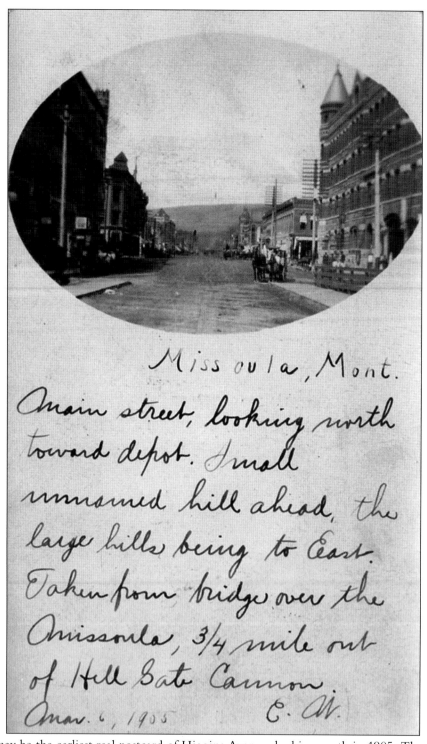

Missoula, Mont.

Main street, looking north toward depot. Small unnamed hill ahead, the large hills being to East. Taken from bridge over the Missoula, 3/4 mile out of Hell Gate Cannon.

Mar. 6, 1905

E. W.

This may be the earliest real postcard of Higgins Avenue, looking north in 1905. The sender has called Higgins Avenue "Main Street." Almost no automobiles would have been on the street at this time. The first one, a crude steamer, was brought to Missoula in 1901.

Two

Buildings, Schools
Churches, Homes,
and Hospitals

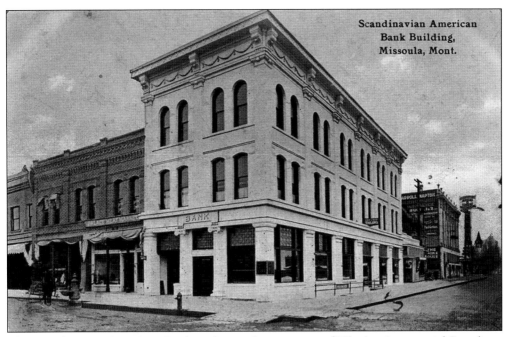

The Scandinavian-American Bank at the northeast corner of Higgins Avenue and Broadway was located in the Gibson Block, designed by A.J. Gibson. The building was replaced in 1955 by the Western Montana Building and Loan Association, now part of the First Security Bank system. The Masonic Temple is down the street.

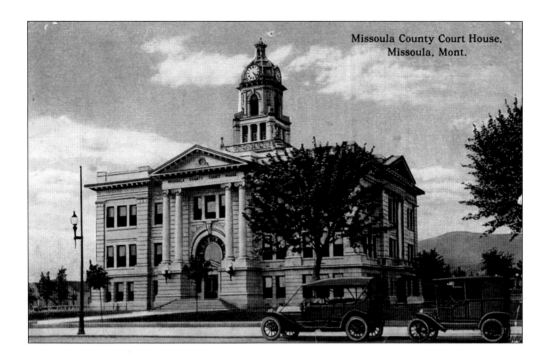

Missoula County Court House,
Missoula, Mont.

Noted architect A. J. Gibson designed the massive stone Missoula County Courthouse, which opened in 1910. A north annex was added in 1966. Eight murals of the Lewis and Clark Expedition on the walls of the south entrance were painted by nationally known Missoula artist Edgar S. Paxon in 1912. The bottom real–photo postcard shows the Doughboy statue placed at the southeast corner of the lawn in 1928 to honor local World War I dead. The old bandstand at the extreme right has been reconstructed at the southwest corner of the lawn.

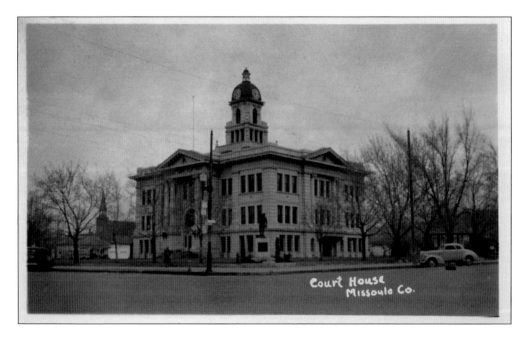

Court House
Missoula Co.

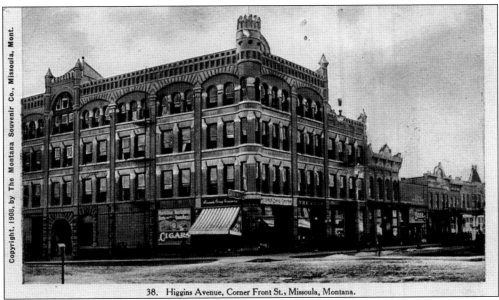

38. Higgins Avenue, Corner Front St., Missoula, Montana.

Prominent city businessman A. B. Hammond built this imposing structure in the 1890s at the southwest corner of Higgins Avenue and Front Street. It housed various businesses and offices. On October 9, 1932, the building was destroyed by fire. In 1934, a one-story building was constructed on the site, named the Hammond Arcade. Only one story was built because of financial conditions of the Great Depression. For many years, the corner was occupied by the Missoula Drug Company.

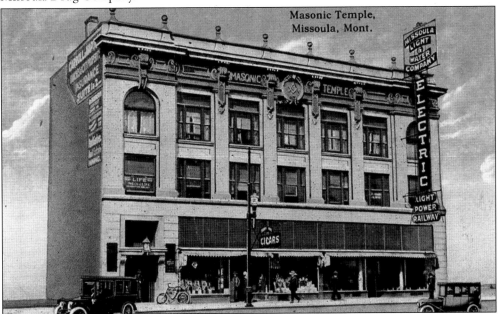

The Masonic Temple building on East Broadway was built in 1909 to house several Masonic orders. It is the only Beaux Arts building in Missoula's central business district. For many years, it was also the office for W. A. Clark's Missoula Light and Water Company, which controlled the electric, water, and streetcar services for the town. Today the building still houses several Masonic orders and other offices and retail on the street level.

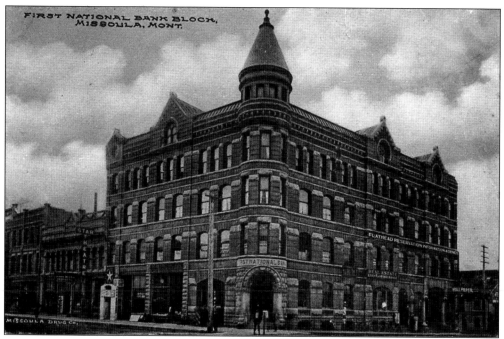

This impressive building at the southeast corner of Higgins Avenue and Front Street was constructed in 1891 and was the home of the First National Bank until it was demolished in 1962. The bank, established in 1873, is the oldest continuously operated bank in Montana, changing its name to First Interstate Bank. The replacement building was torn down in 2007 to make way for a new six-story bank building.

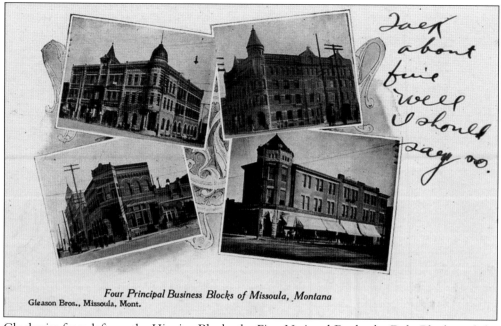

Four Principal Business Blocks of Missoula, Montana
Gleason Bros., Missoula, Mont.

Clockwise from left are the Higgins Block, the First National Bank, the Daly Block, and the Union Block.

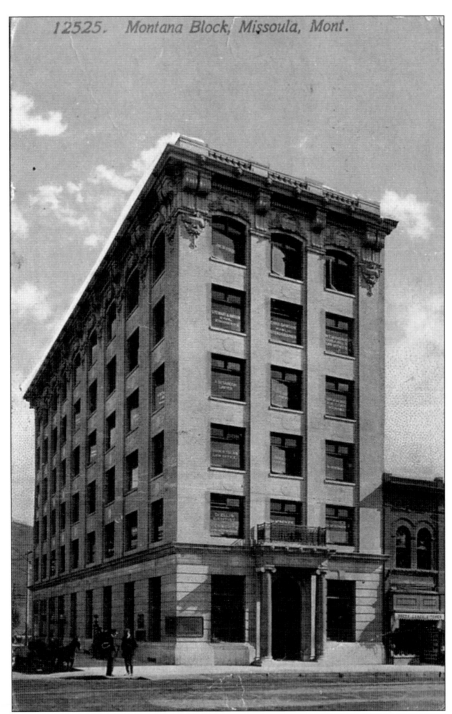

The Montana Building on the corner of Broadway and Higgins Avenue was built in 1909 and is one of the most prominent buildings in downtown Missoula. The facade has been considerably altered through the years. On April 11, 1911, ex-president Theodore Roosevelt spoke from a platform at the building's corner to a large gathering. For years, the Western Montana National Bank occupied part of the building.

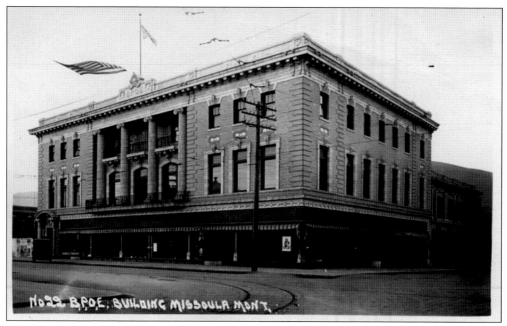

The impressive BPOE (Elks Club) building on Pattee Street was built for Hellgate Lodge No. 383 in 1911 and is still in use. The bottom floor was used for years as a sales area for the Missoula Mercantile Company. The lodge was established in Missoula on July 31, 1897, with other lodges in the state sending delegates to the city for a two-day ceremony. The first officers of the lodge were J. M. Keith, George Boos, Joseph Dixon, and C. A. Barnes.

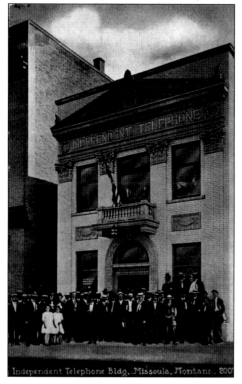

The neoclassical-style Independent Telephone Company building on East Main Street was opened in 1910. It later served as the local chamber of commerce headquarters and is at present a retail outlet.

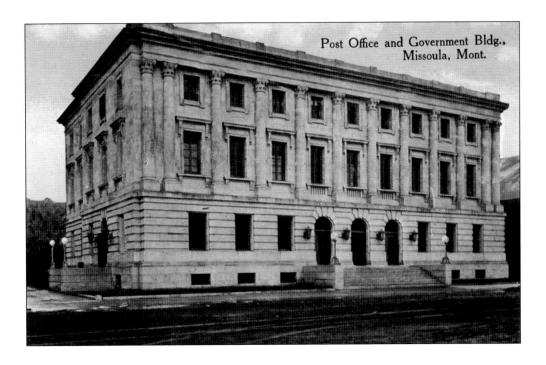

Post Office and Government Bldg., Missoula, Mont.

The impressive Federal Building/Post Office on Broadway was completed in 1913 and housed the post office and the regional headquarters of the U.S. Forest Service. The east addition was built in 1928, and the last addition, built to house the forest service offices, was opened in 1936. The federal court has since moved across the street to the Russell Smith Courthouse.

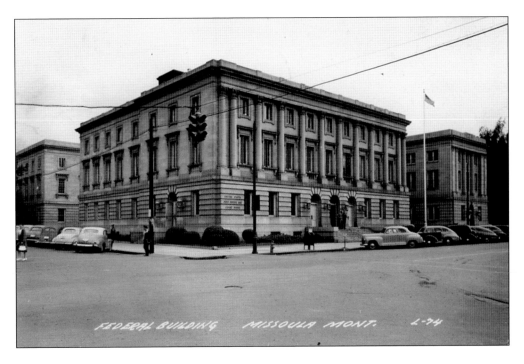

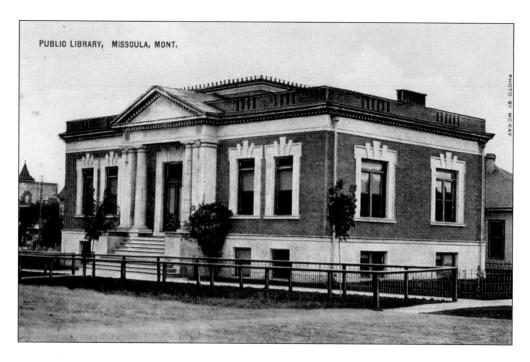

The Missoula Art Museum is now located in the remodeled old Carnegie Library on Pattee Street. In 1902, the city purchased a lot from J. M. Keith and constructed a one-story public library with $12,500 provided by the Carnegie Foundation. A. J. Gibson was the architect. In 1913, a second story, designed by Ole Bakke, was built. The library moved to its present site in 1974, and the old library building was taken over by the art museum. In 2007, the building was remodeled and an adjacent annex was added.

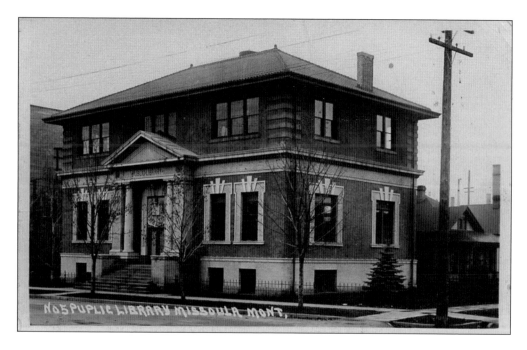

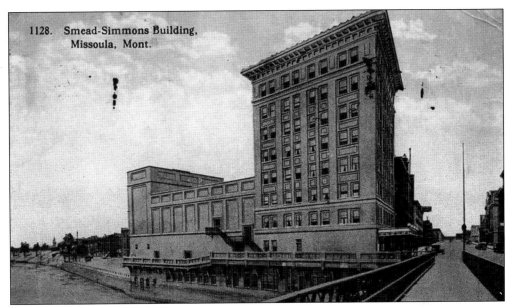

1128. Smead-Simmons Building, Missoula, Mont.

The most prominent building in downtown Missoula for many years was the Smead-Simons Building, now known as the Wilma Building. It was opened in 1921 by W. A. Simons. The building had a theater named for Simons's wife, Wilma. A large pipe organ was installed and is still in place. There were apartments on the upper floors, a swimming pool in the basement, and a café. The building has been restored and still houses a theater, restaurant, office and apartments.

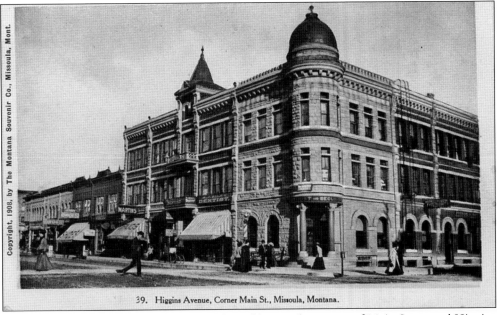

Copyright, 1908, by The Montana Souvenir Co., Missoula, Mont.

39. Higgins Avenue, Corner Main St., Missoula, Montana.

The C. P. Higgins Western Montana Bank Building at the corner of Main Street and Higgins Avenue was completed in 1889, which is the same year the well-known local businessman died. Higgins, along with Francis Worden, was one of the founders of Missoula. He was at Gov. Isaac Stevens's party when a treaty was signed at Council Grove, west of Missoula, with the Native Americans in 1855. The building now houses the Sterling Savings Bank.

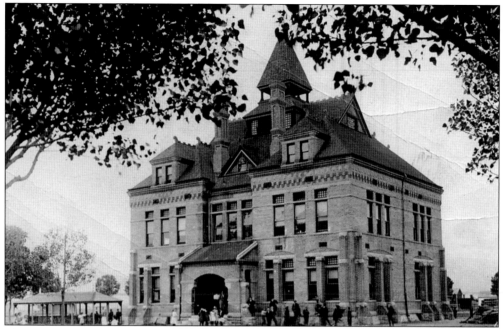

This 1912 view is of the Southside Grade School on South Sixth Street. It was built in 1891, and from 1895 to 1898, was used by the new University of Montana, with citizens of Missoula raising money to renovate the building. After the university moved to its present campus, the building continued as a grade school and as the second home for the high school. In 1920, the building was demolished and the Willard School was built on the site.

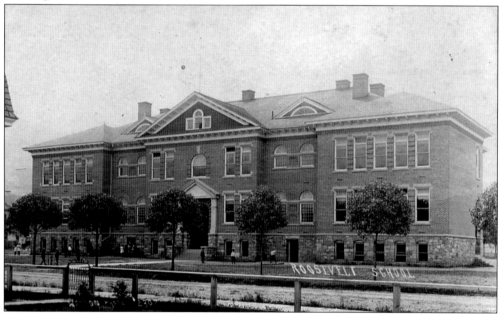

The first building built as a four-year high school was opened in 1904 on South Sixth Street. This building was soon overcrowded, and it reverted back to a grade school (Roosevelt) in 1908, when a new high school building was opened. It now holds offices for Missoula County Schools.

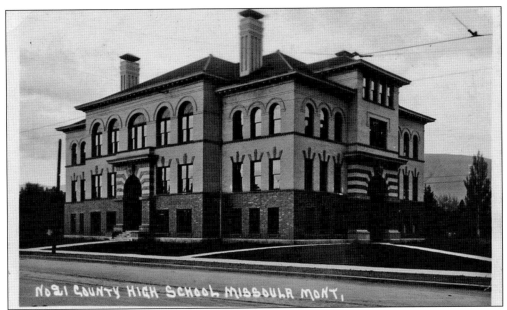

Missoula County High School's permanent home was this building on South Higgins Avenue that opened in November 1908. It was designed by Missoula architect A. J. Gibson. The first floor had seven rooms, the second floor had seven rooms and two offices, and the third floor consisted of an assembly hall and four rooms. Many additions and a major fire in 1931 have transformed the building, but the original core of the building is incorporated in present Hellgate High School.

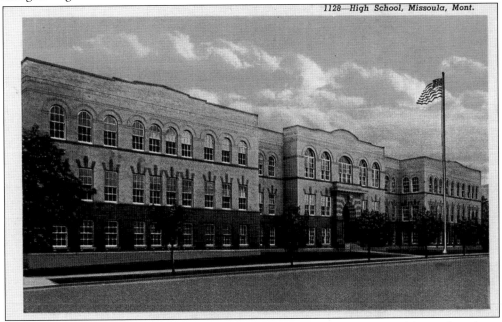

1128—High School, Missoula, Mont.

The present Hellgate High School building is shown as it looked in 1941. Additions have been added to the north and south sides and on the back side. Hellgate became a four-year high school in 1965 when it and Sentinel High School split into two separate schools. Missoula's third public high school, Big Sky, was opened in 1980.

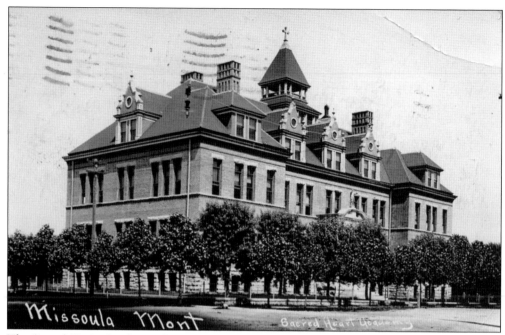

The Sacred Heart Academy, designed by A. J. Gibson, was opened in 1900. An addition was added in 1902 and used as St. Joseph Grade School. The academy was a girls' school for years and later became coed. It was closed and was demolished in 1979.

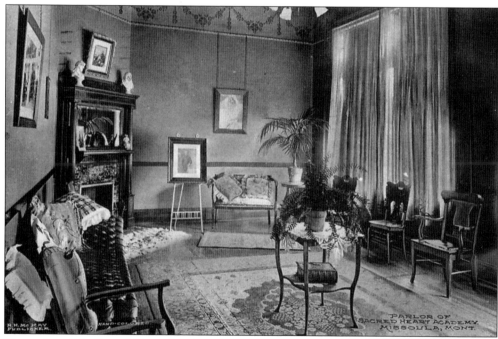

The parlor of the Sacred Heart Academy is seen here as it looked in the 1920s.

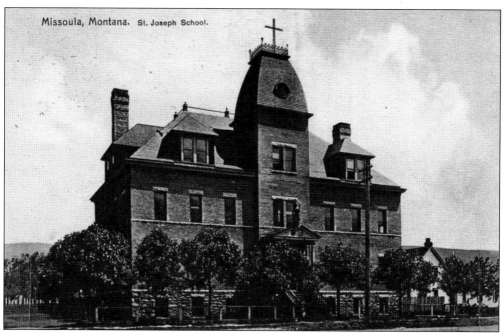

St. Joseph Grade School was located in the Catholic Block behind Sacred Heart Academy. It was an addition to the academy and opened in 1902. It was used until 1927, when a new building was opened and the old school was used as a boarding department. In 1957, the building was torn down. Today St. Joseph Grade School is in the former Roosevelt Grade School building at the corner of Edith and Beckwith Streets.

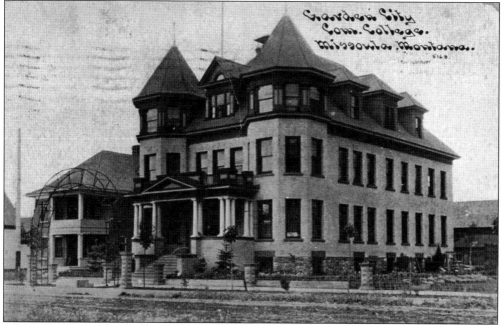

The Garden City Commercial College at 120 South Fourth Street was designed by A. J. Gibson and opened in 1902. The Queen Anne–style building was converted to the Babs Apartments in the 1930s.

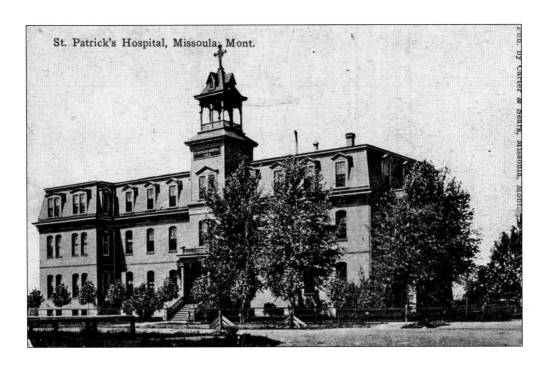

St. Patrick's Hospital, Missoula, Mont.

The first St. Patrick Hospital was established by the Sisters of Providence in 1873, and in 1889, this large building was opened (top). In 1923, a new hospital building was built next door (below in a 1944 view), and a large brick wing added in 1947. The 1873 building was torn down in 1964, and today the St. Patrick Hospital and Health Sciences Center, and the Western Montana Clinic occupy the entire block.

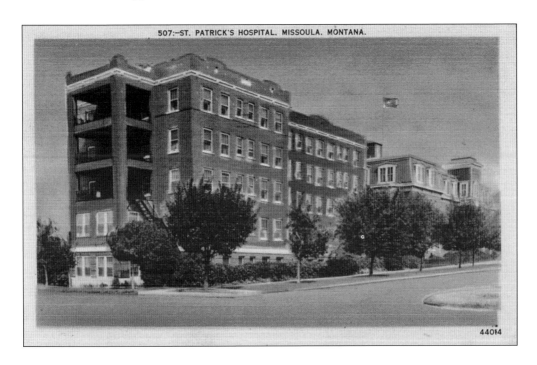

507:—ST. PATRICK'S HOSPITAL, MISSOULA, MONTANA.

44014

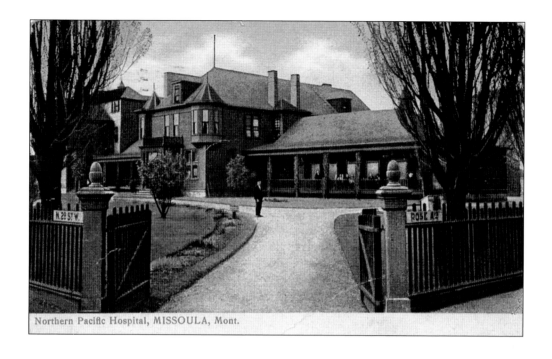

Northern Pacific Hospital, MISSOULA, Mont.

This is the second Northern Pacific Railway hospital on North Second Street (top). The first hospital, built in 1888, burned down in 1892, and this building replaced it in 1893. It was owned by the Northern Pacific Beneficial Association. This building partially burned in 1916, and a new 116-room building replaced it the next year (bottom). In 1967, it was renamed the Missoula General Hospital; it closed in the 1980s and was torn down.

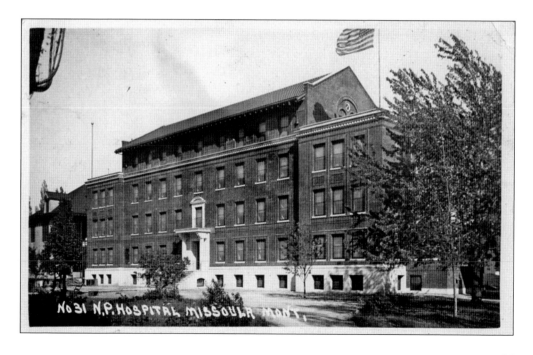

No31 N.P. HOSPITAL MISSOULA MONT.

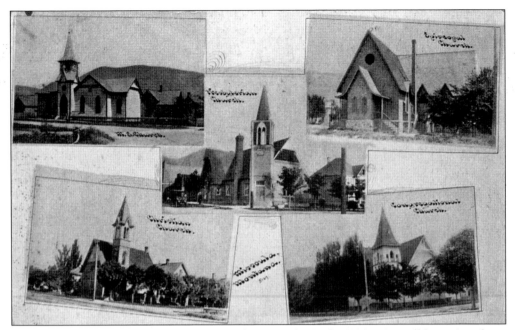

Some of the early churches in Missoula are shown in this early-1900s view, all have since been replaced by new buildings.

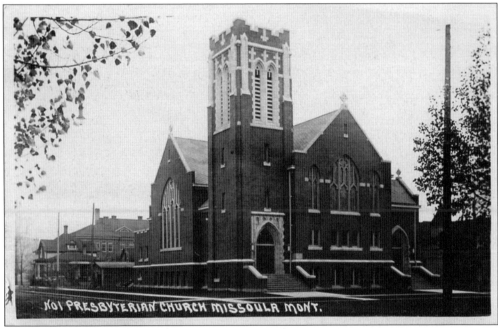

The First Presbyterian Church on South Fifth Street was designed by A. J. Gibson in the Gothic Revival style. It opened in 1915, and present at the cornerstone dedication was the church's pastor, Rev. John Norman Maclean. His son, Norman, who was later a professor at the University of Chicago, wrote the short story "A River Runs Through It" that was made into a popular movie of the same name.

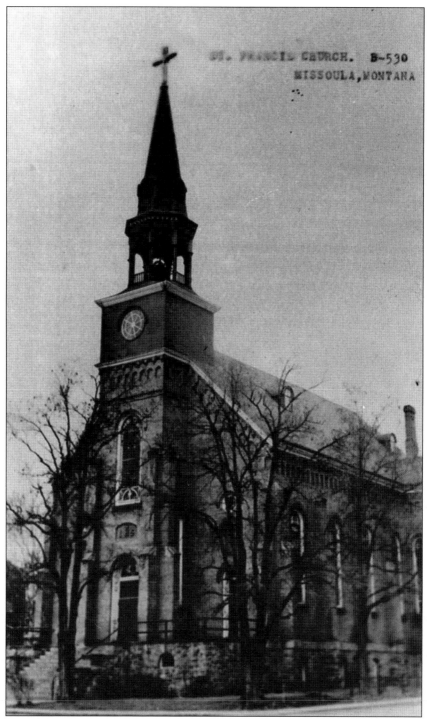

The historic St. Francis Xavier Church has been at this site since it was constructed in 1892. Murals inside the church were painted by Br. J. Carignano, who also painted the murals at the St. Ignatius Mission. Fr. L. B. Palladino, noted author on Native American–white relations in Montana, served as the priest for many years. The bell in the steeple is dedicated to him.

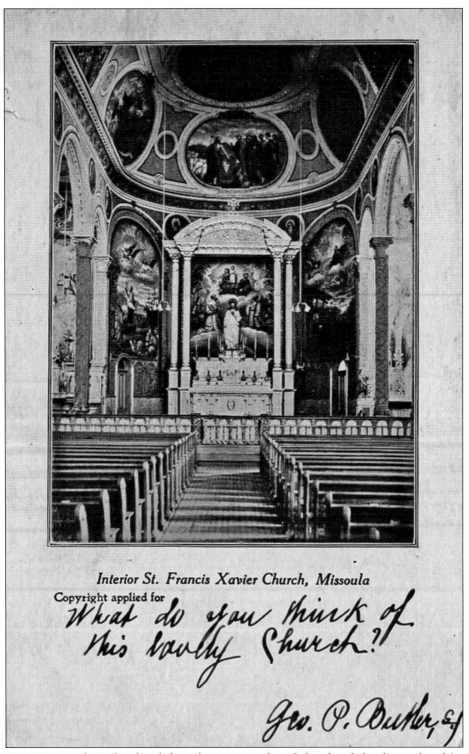

Interior St. Francis Xavier Church, Missoula

Copyright applied for

What do you think of this lovely Church?!

Geo. P. Butler, S.J.

The interior murals in the church have been restored, and the church has been placed in the National Register of Historic Places.

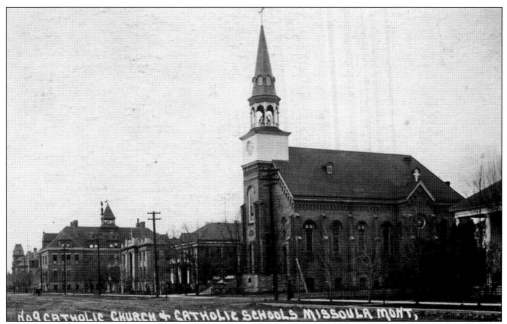

By the 1920s, the Catholic Block consisted of the St. Francis Xavier Church (1892), the rectory (1910), Loyola High School (1911), Sacred Heart Academy (1900), St. Joseph School (1902), and St. Francis School (1927), not shown, all located between West Pine, West Spruce, Orange, and Owen Streets.

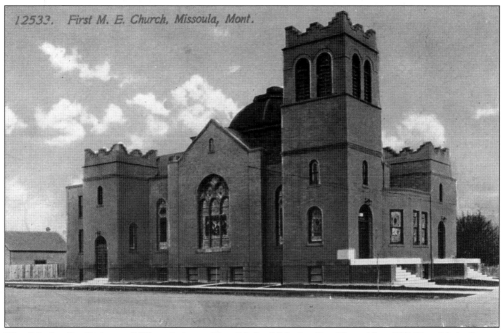

The Methodist Episcopal Church (now First United Methodist Church) at 300 East Main Street was constructed in 1911. Its castle-like towers are a feature of Gothic Revival architecture, and the center dome shows an Eastern European church influence.

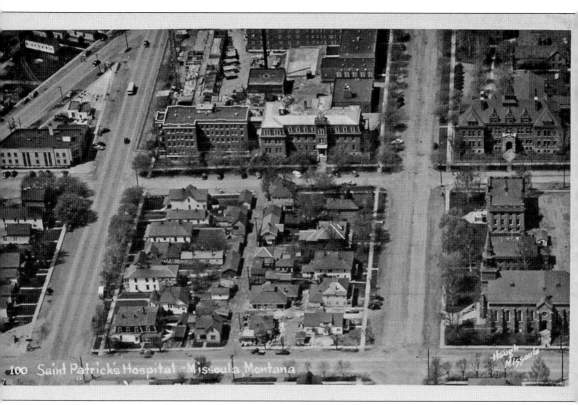

100 Saint Patrick's Hospital - Missoula, Montana

This 1947 aerial view shows St. Francis Xavier Church in the lower right, the rectory next door, Loyola High School, and, across the street, Sacred Heart Academy. In the center is the 1889 St. Patrick Hospital, the new brick building and the newest hospital structure facing Broadway, which is under construction. Across Broadway is the Western Montana Clinic. The present St. Patrick Hospital and Health Sciences Center occupies all of the two blocks at the top of the card.

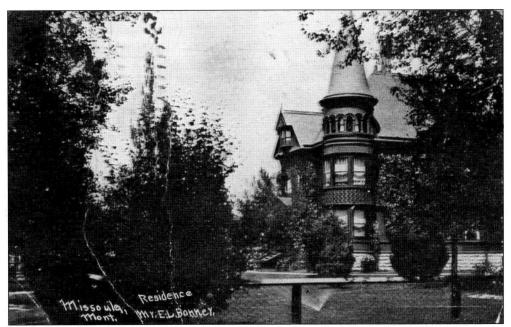

The Bonner Mansion stood at 910 Gerald Avenue. Construction began in 1891 and was completed two years later at a total cost of $35,000. The mansion was torn down in 1959 after Missoula schools declined to accept the home for their use, and an apartment complex was built on the site. The second-floor landing was reached by means of a grand staircase leading from the hall below to a similar one above. The windows lighting the staircase were stained glass. On the second floor were a 16-by-22-foot billiard room and six large bedrooms.

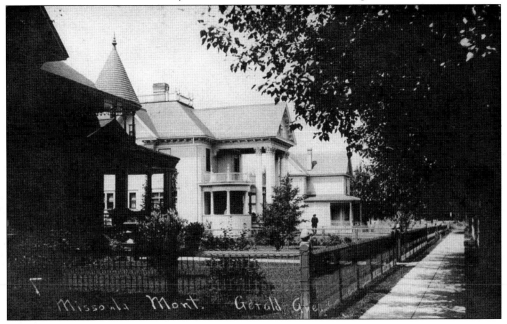

Elegant homes were built in the early 1900s in the University District, now part of a National Register Historic District. These homes were on the 800 block of Gerald Avenue. The Peterson Mansion is the large home with columns in the middle.

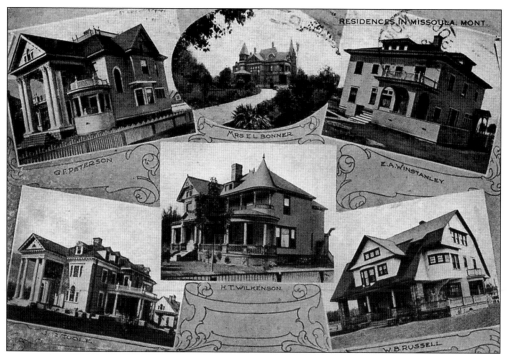

Of these homes in Missoula in 1909, only the Peterson and Toole homes are still in existence. The Peterson home is now located on 39th Street, and the Toole home is on the original location as the home of the Kappa Kappa Gamma sorority. The Russell home is now the Sigma Alpha Epsilon fraternity house.

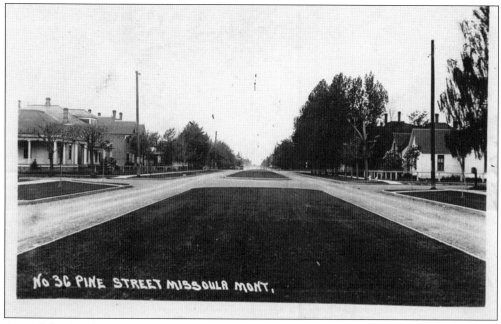

One of the first historic districts designated in Missoula in the National Register of Historic Places was the East Pine Street Historic District in downtown Missoula. It is roughly bounded by East Pine Street, Madison Street, East Broadway, and Pattee Street.

Three

FIRE AND FLOOD

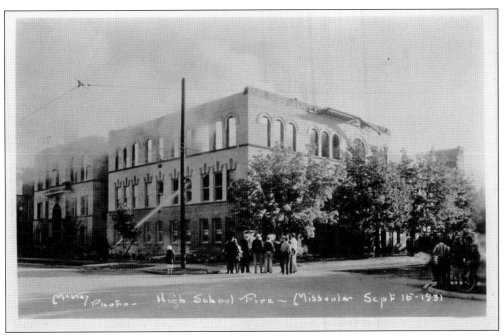

Missoula County High School had a spectacular fire on September 15, 1931. Although the roof and interior of the structure were destroyed, most of the brick walls remained standing and were used in the building reconstruction. A flat roof was put on. The school has been Hellgate High School since 1965.

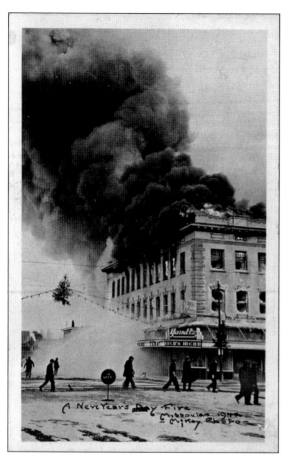

One of Missoula's worst fires occurred on January 1, 1942, when the Ross Block and the Shapard Hotel on North Higgins Avenue burned down. The temperature reached 15 degrees below zero, which impeded firefighting efforts. The total damage was $350,000.

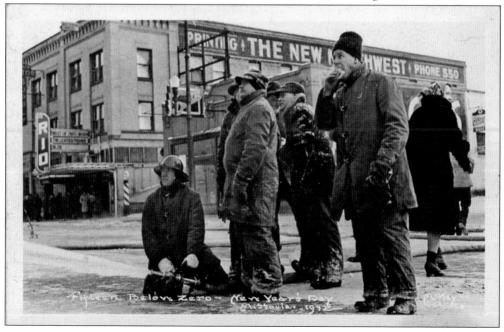

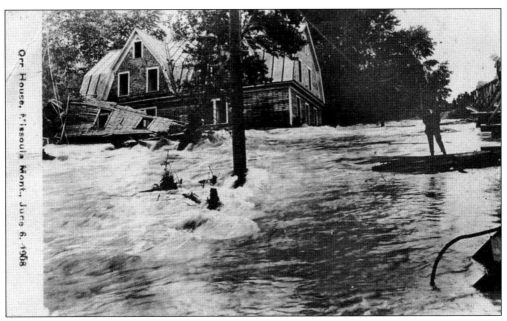

Missoula's greatest natural disaster was the June 1908 flood of the Clark Fork River (called the Missoula River at the time). After 33 days of continuous rain, warm weather, and heavy runoff from winter snow, the river overflowed and inundated parts of the downtown and outlying areas. Railroad tracks were destroyed, several bridges were destroyed, and houses floated down the river.

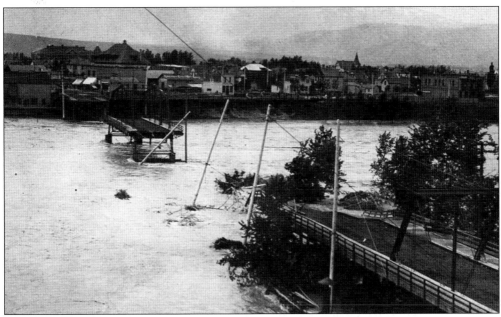

The 1890 Higgins Avenue Bridge teetered on the brink of destruction for several days until it collapsed on June 5. This cut off the downtown section of the town from the southside. A temporary footbridge, called the "bounding bridge" because of its swaying nature, was built, connecting the two piers. In October, another temporary footbridge was constructed to the east of the washed-out bridge, and in 1909, a new bridge was built. It was replaced in 1962.

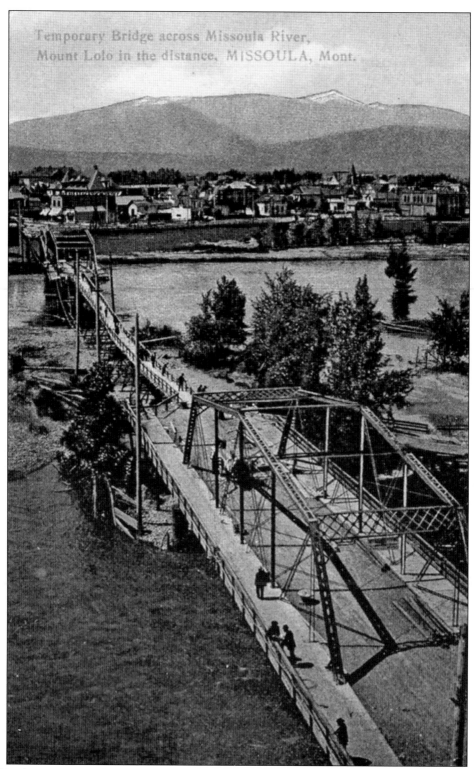

Temporary Bridge across Missoula River,
Mount Lolo in the distance. MISSOULA, Mont.

This close-up view of the footbridge on the Higgins Avenue Bridge is looking south.

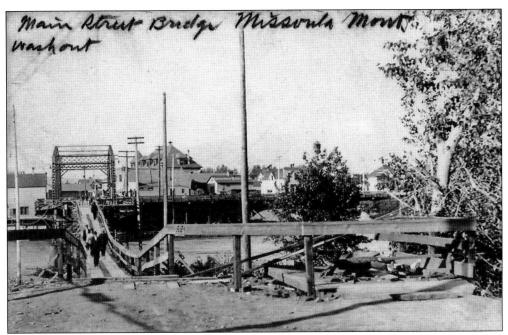

Another view looks south of the footbridge. The Garden City Commercial College is the large building in the background.

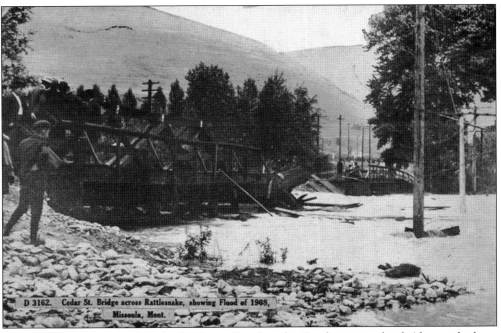

The Cedar Street (Broadway) bridge across Rattlesnake Creek was another bridge washed out by the flood.

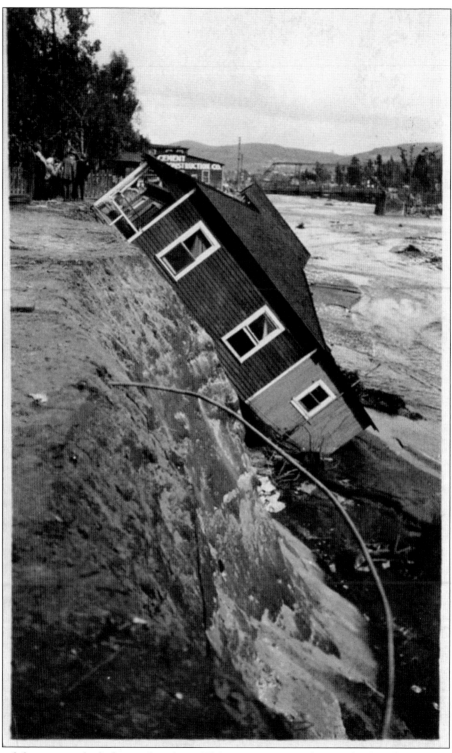

Several houses washed down the river. This one was on the southside of town east of the bridge.

Four

IN THE AIR AND ON THE RAILS

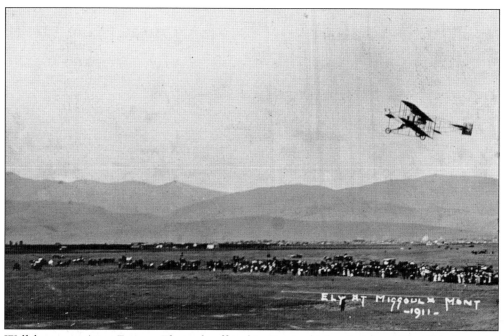

Well-known aviator Eugene Ely took off in his Curtiss biplane on June 26, 1911, from the ballpark at Fort Missoula in the city's first aviation event. A sizable crowd, part of which came to Missoula by train from the Bitterroot Valley, watched as Ely circled the valley. He was also the first aviator to fly off the deck of a naval ship in November 1910 and the first to land on a naval ship in January 1911.

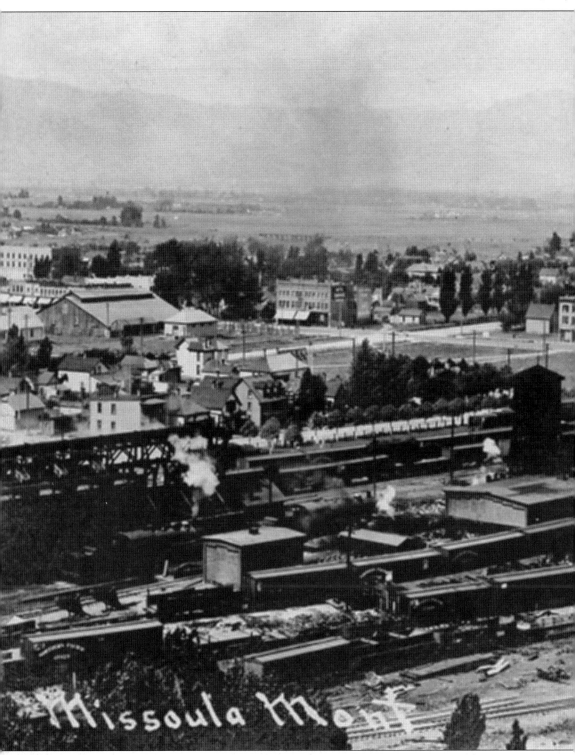

The Northern Pacific Railway reached Missoula in 1883, and soon the city was a major railroad hub with a large rail yard and roundhouse on the north end of town. Today Montana Rail Link

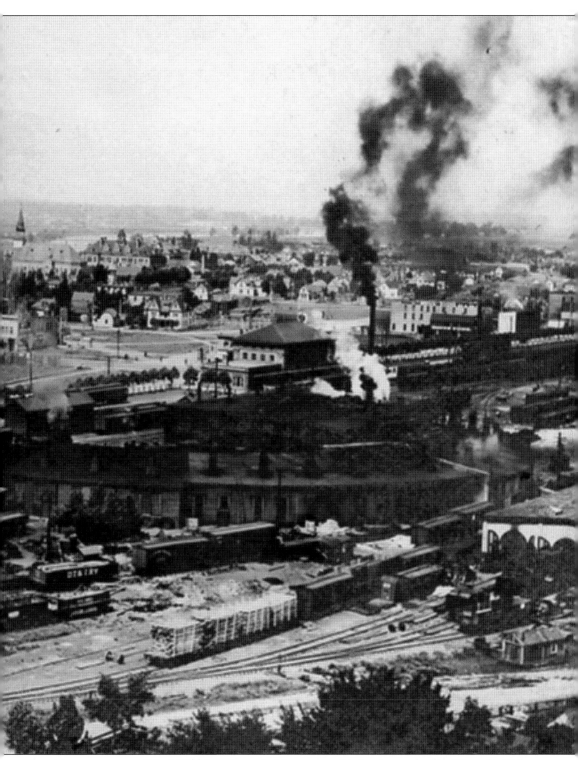

has taken over most of the NP right-of-way in Montana and is headquartered in Missoula. This view is now open space, and the rail yard has moved to the western edge of town.

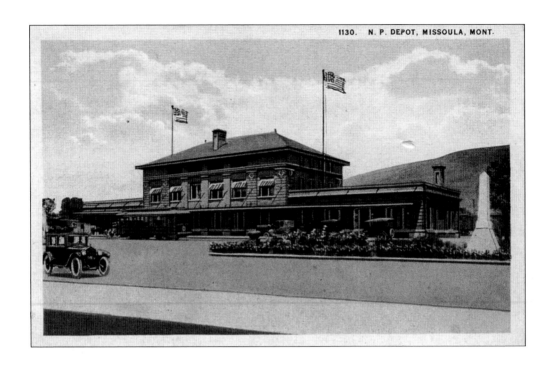

A depot was under construction at the north end of Higgins Avenue in the mid-1890s but was destroyed by arson in 1896 before completion. This depot, just to the east, was opened in 1901. The top view is of the front with the Mullan statue to the right. The bottom view is the back side by the tracks. The building is owned by the Washington Corporation and is used as office space.

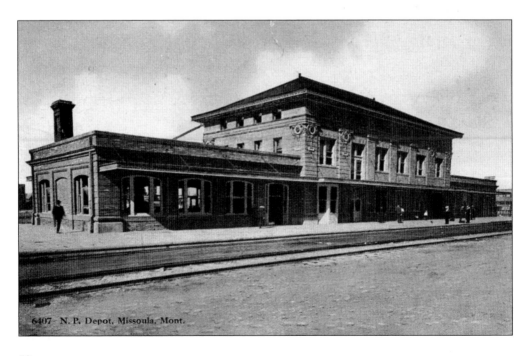

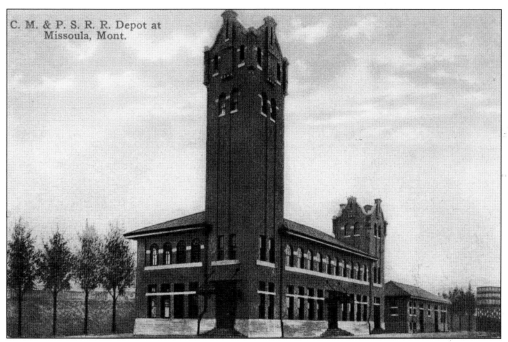

C. M. & P. S. R. R. Depot at Missoula, Mont.

The Milwaukee Road had its beginnings in Wisconsin in 1847. In 1874, the company became the Chicago, Milwaukee, and St. Paul Railway and, in the early 1900s, began a transcontinental expansion to the Seattle/Tacoma area. Rails reached the state in 1907 and Missoula in 1909, with a golden spike ceremony held on May 9, 1909, four miles west of Garrison, Montana. The line was electrified between Harlowton, Montana, and Avery, Idaho, in 1916 and later converted to diesel. Passenger service was discontinued through Missoula in 1961, and the railroad ran its last train through town in 1980, the year it went bankrupt. Today the elegant depot is home to the national headquarters of the Boone and Crockett Club.

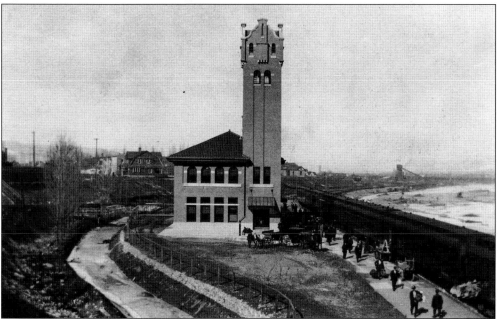

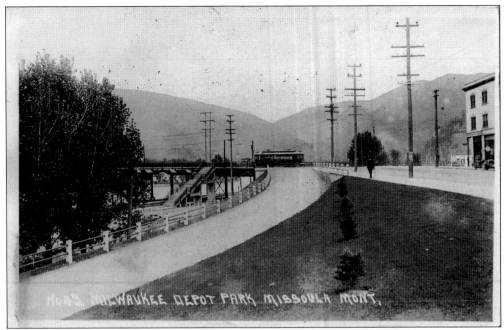

The south end of the Higgins Avenue Bridge shows the road down to the Milwaukee Road depot. A streetcar is on the bridge, and the Penwell Hotel is on the right. The bridge has been replaced, the Penwell is now apartments, and the road still leads down to the old depot. A small park is now in the grassy area.

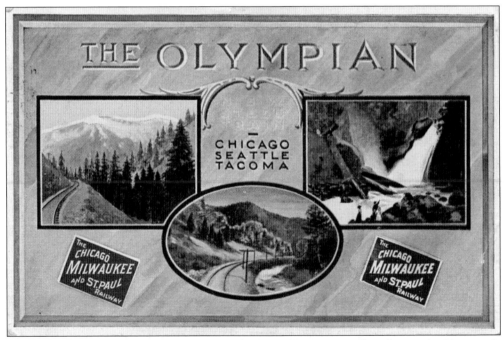

The Olympian was the pride of the Milwaukee Road's passenger fleet for nearly 50 years. It started operation between Chicago and the Pacific Coast in 1912 and was called the Hiawatha after it was converted to diesel.

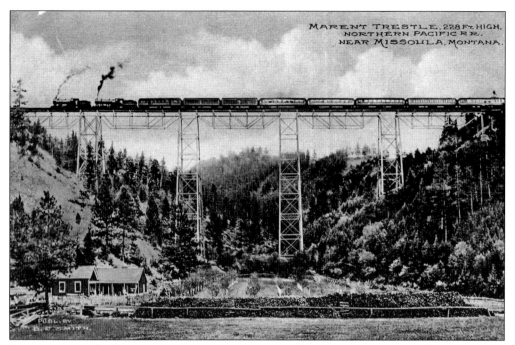

At the lower end of Evaro Canyon is the Marent trestle on the Northern Pacific Railway. At the time it was built in 1883, it was the highest wooden railroad trestle in the world at 226 feet. Two years later, it was replaced by this steel structure (bottom), which is still in use today.

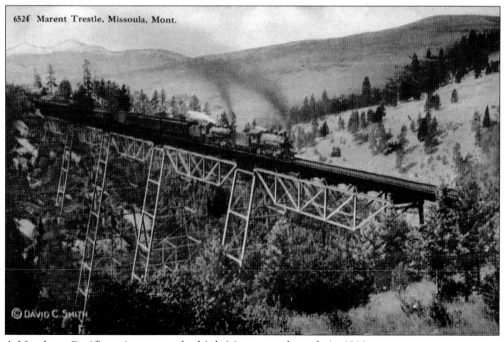

A Northern Pacific train crosses the high Marent steel trestle in 1910.

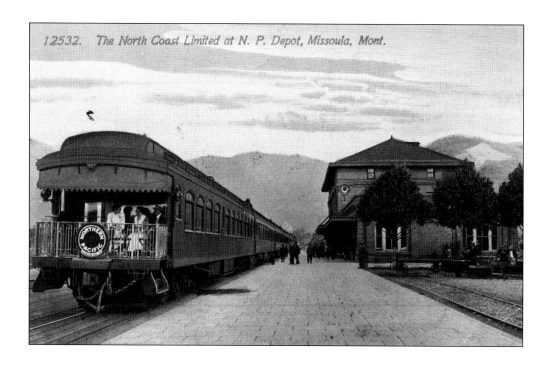

12532. The North Coast Limited at N. P. Depot, Missoula, Mont.

The North Coast Limited of the Northern Pacific Railway first came through Missoula on May 1, 1900. It was a modern train with steam heat, dining car, observation car, plush Pullman sleeping cars, and even a barbershop. Later the train included a library, card room showers, and a soda fountain. The train is shown at the NP depot in 1913. The last NP passenger train left Missoula in 1971, and Amtrak left in 1979.

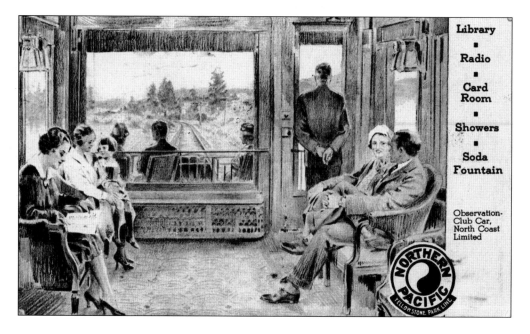

Library
•
Radio
•
Card
Room
•
Showers
•
Soda
Fountain

Observation-
Club Car,
North Coast
Limited

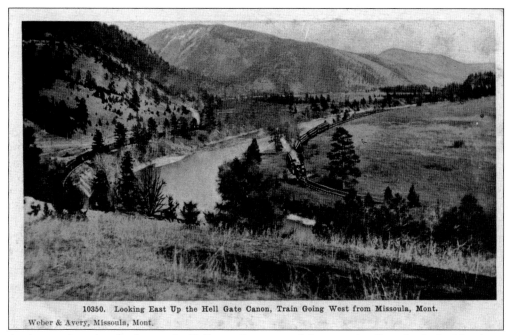

10350. Looking East Up the Hell Gate Canon, Train Going West from Missoula, Mont.
Weber & Avery, Missoula, Mont.

An interesting view looks east in Hellgate Canyon and shows trains from both the Northern Pacific and Milwaukee Road right-of-ways that served Missoula.

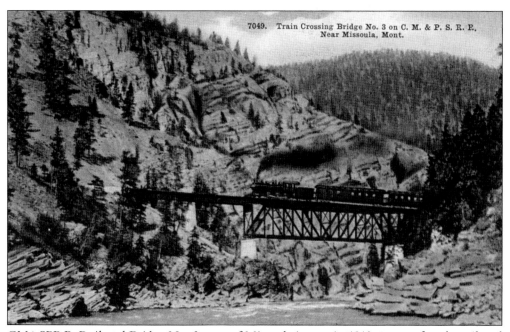

7049. Train Crossing Bridge No. 3 on C. M. & P. S. R. R.
Near Missoula, Mont.

CM&SPRR Railroad Bridge No. 3 west of Missoula is seen in 1910, a year after the railroad was completed in Montana.

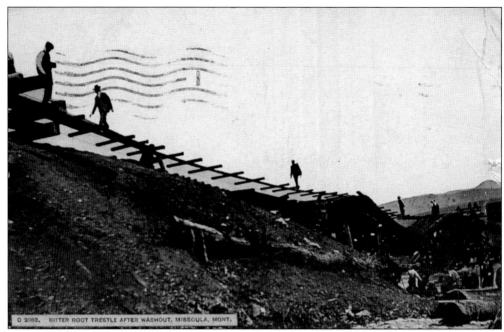

The trestle on the Bitterroot Branch of the NP suffered considerable damage from the 1908 flood. The branch, which went to Darby in the Bitterroot Valley, used to haul lumber from sawmills in the valley to the mainline in Missoula, but today it is only used about three times a week for general freight.

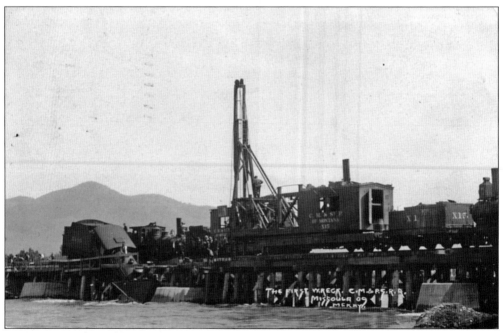

Soon after the Milwaukee Road came to Missoula, there was a major wreck in April 1909 on the bridge that spanned Spring Gulch.

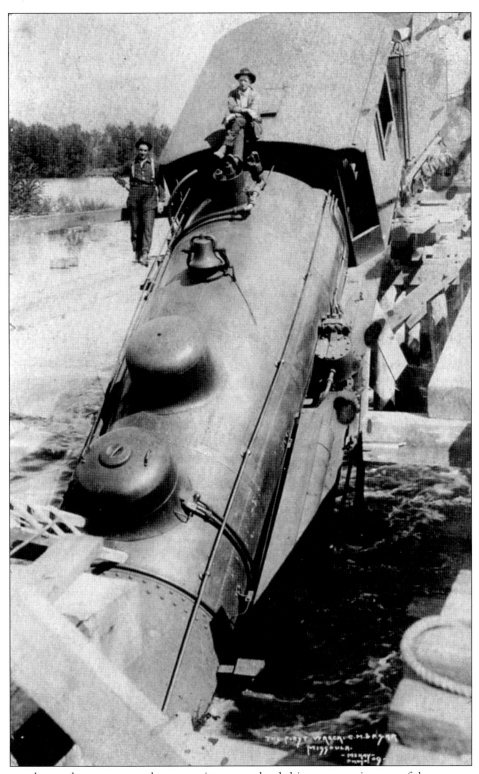

It must have taken some very heavy equipment to haul this steam engine out of the water.

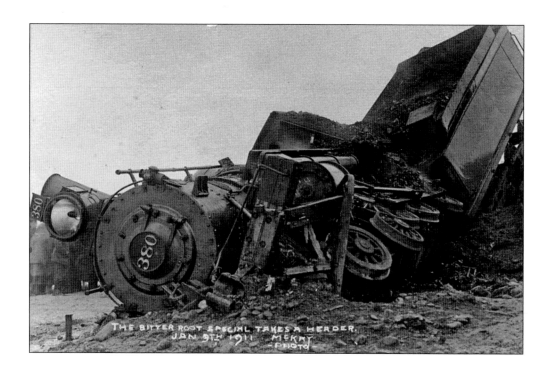

Wrecks on both railroads were common in the steam engine days. The top view was taken on January 9, 1911, on the Bitterroot Branch. The bottom was a wreck in the Clark Fork River on July 7, 1938.

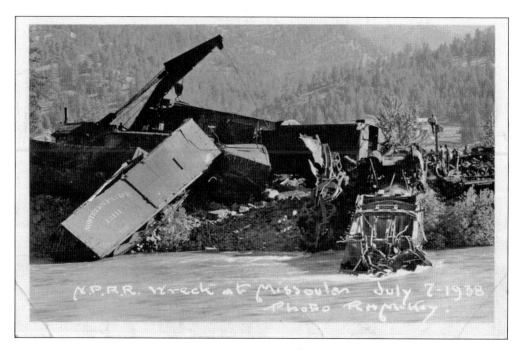

Five

Parades, Fairs, and Exhibits

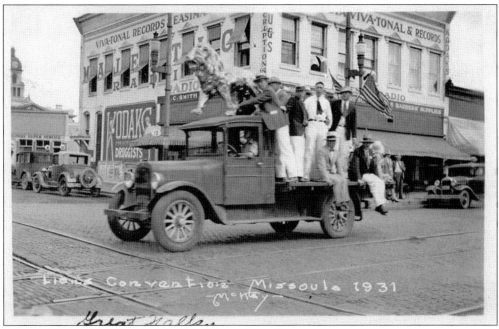

A Lions Club convention was held in Missoula in 1931. This group is apparently from the Great Falls club. Notice the brick paving on the street, which is at the corner of Higgins Avenue and Broadway. The building in the background was the Smith Drug Store. The courthouse is in the left background.

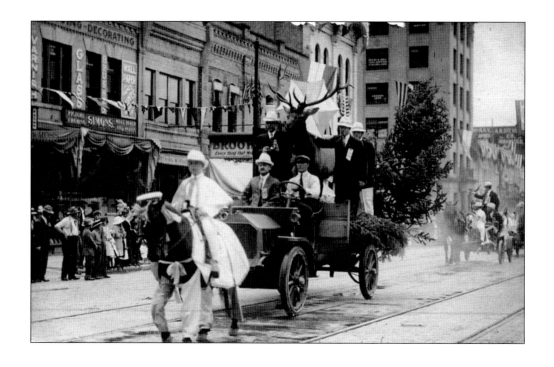

The local Elks Club participated in a 1909 Fourth of July parade in downtown Missoula. Notice the stuffed elk in the back of the car along with some trees.

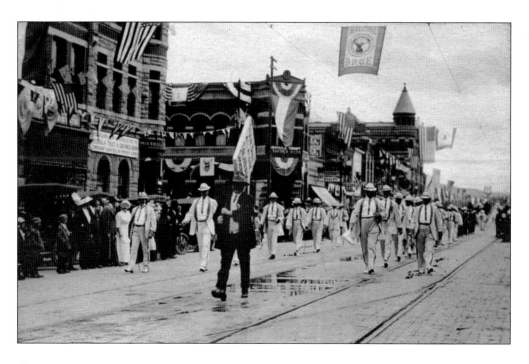

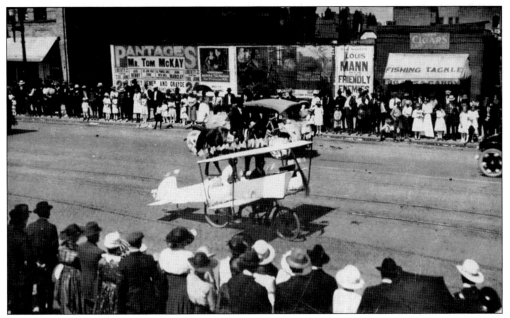

No date was on this card, but it is a parade on Higgins Avenue in the early 1900s. Two men have built an early airplane replica mounted on a bicycle.

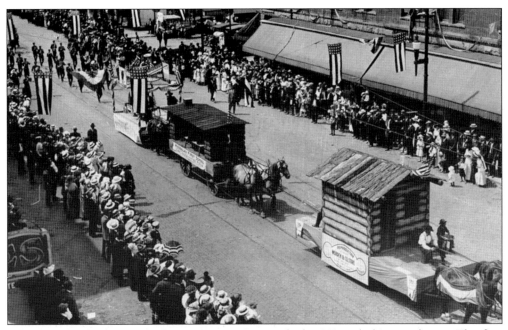

This Fourth of July parade down Higgins Avenue had a Missoula history theme. The first float depicts Worden and Company, the first store at old-Hellgate Village. The next honors Emma Dickinson, Missoula's first schoolteacher, who was hired in July 1869. The Missoula Mercantile is on the right. This card is undated.

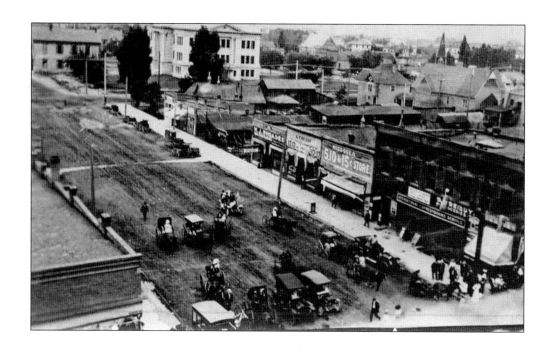

These rare postcards show a parade on July 4, 1910, in downtown Missoula. The top view is on Cedar Street with people and cars lined up to watch the parade. The new courthouse is the background. The bottom view, looking north, shows many businesses on Higgins Avenue along with some horse-drawn fire equipment and a military unit. A Barnum and Bailey circus poster can be seen on a building.

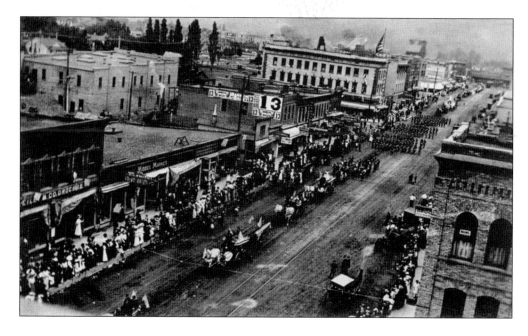

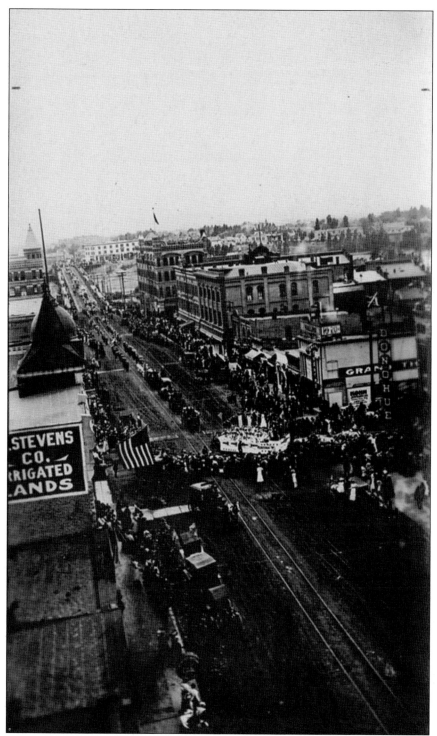

The parade is turning west on Main Street. The building on the left is the top of the Higgins Block. Notice what appears to be a large ship model float with the word "Montana" written on the side.

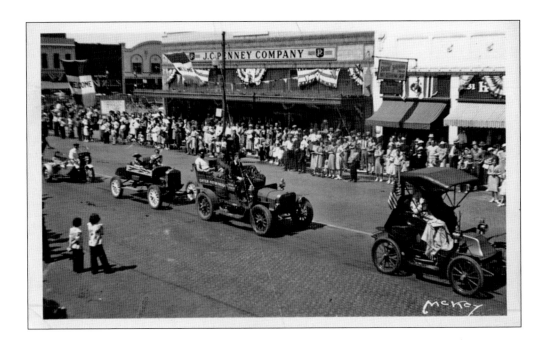

Another Fourth of July parade, this one was in 1939. The site behind the welcome banner is where the Florence Hotel burned down in 1936. A new hotel building would not be opened until 1941.

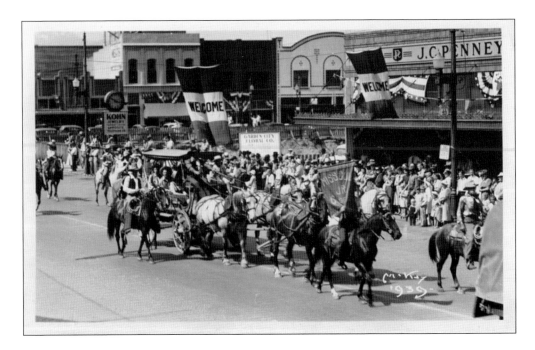

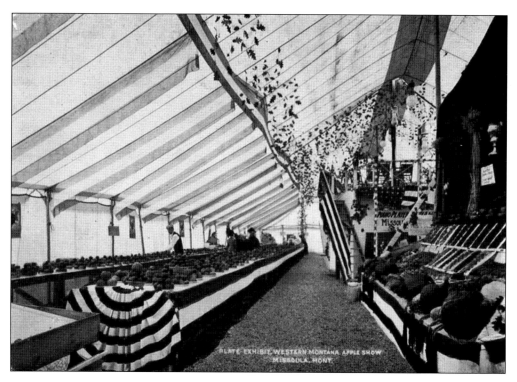

In 1909 and 1910, an apple show was held in Missoula, probably at the old fairgrounds off of present-day Reserve Street. Apples were a major crop in the Bitterroot Valley for many years in the past century. They were shipped to Missoula for distribution nationwide. The top view shows plates of apples; the bottom view has advertisements for cooking with both gas and electric.

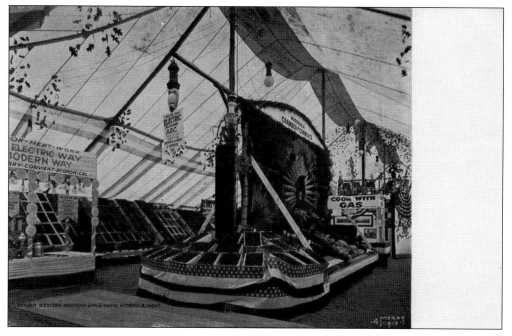

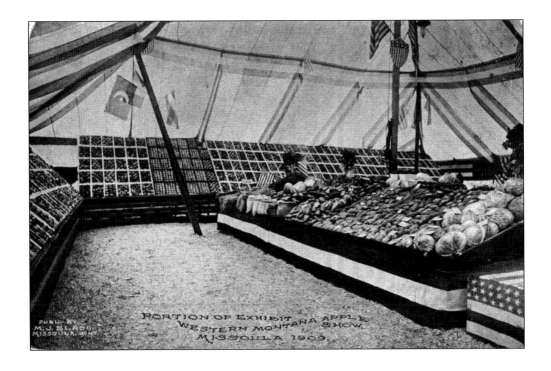

The above card shows another view of the 1909 Western Montana Apple Show. The bottom card shows a plate of McIntosh apples from the 1910 show.

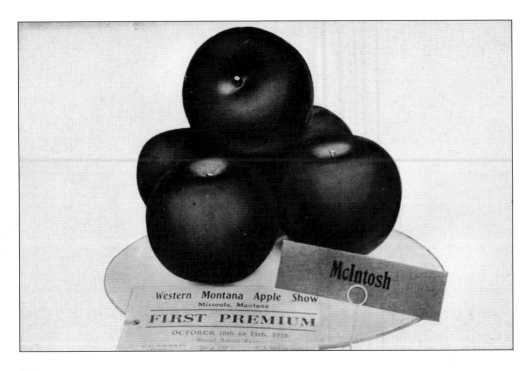

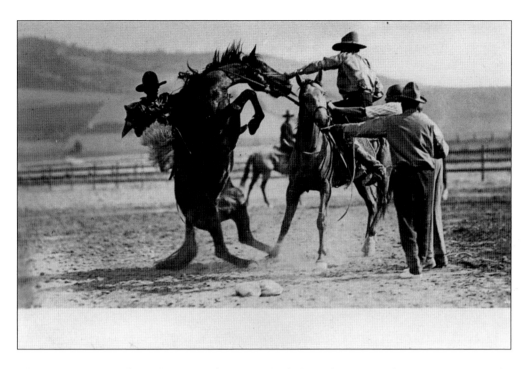

These postcards are from the Missoula Stampede, held at the present fairgrounds around the Fourth of July holiday in 1915, 1916, 1917, and 1918. The back of one of the cards reads, "If you want a real treat visit the Missoula Stampede and Indian Congress on July 2, 3, 4, 5. It's the best show you'll ever see and can't afford to miss it. Be sure and tell your friends about it. It's the biggest thing in the Northwest this year. Don't forget the date."

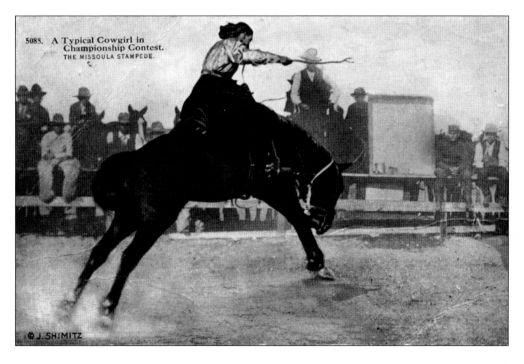

5088. A Typical Cowgirl in
Championship Contest.
THE MISSOULA STAMPEDE.

© J. SHIMITZ

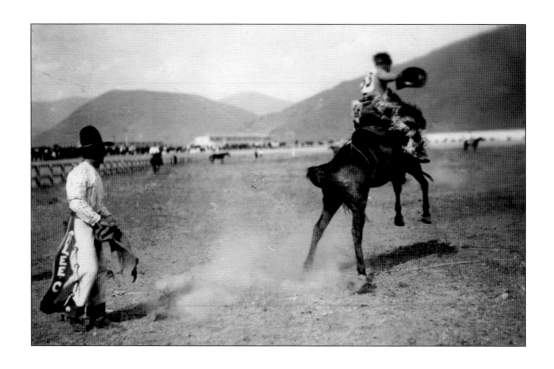

These cards show more views of the Missoula Stampede. A rodeo was a major event during the Stampede.

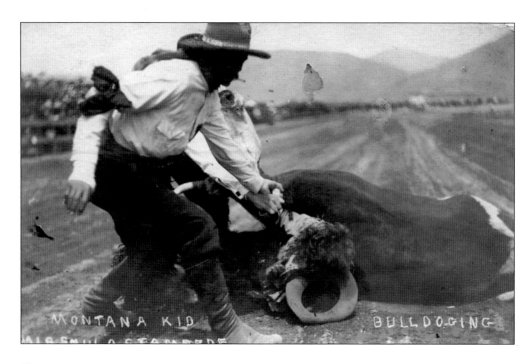

Six

BUSINESS AND INDUSTRY

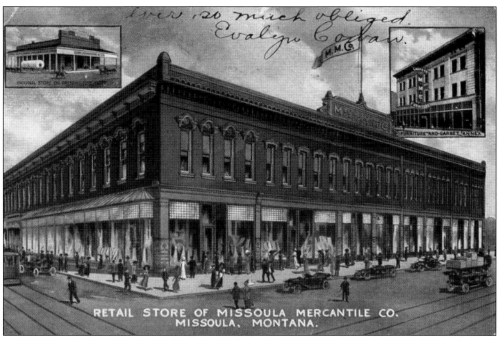

RETAIL STORE OF MISSOULA MERCANTILE CO.
MISSOULA, MONTANA.

The Missoula Mercantile was established in 1886 through a partnership of E. L. Bonner, D. J. Welch, and Richard A. Eddy. The first name of the business was Bonner and Welch before it became E. L. Bonner and Company in 1871. A. B. Hammond joined the firm in 1876. The store moved to its present location in 1877 and was renamed the Missoula Mercantile when it was incorporated in 1885. Charles H. McLeod arrived in Missoula in 1880 to work for Hammond; he would work for the store for 60 years, making it the leading wholesale and retail operation in western Montana. The current building was completed in 1904 and incorporated the 1877 building. It has been modified through the years but still holds it original turn-of-the-20th-century character.

Missoula. Mont.

This 1908 card shows the entire building at the time. Although the second–story windows on the Higgins Avenue side have been bricked in, the building retains virtually the same look today. Bon Marche bought out the historic business and then it sold to Macy's Department Store.

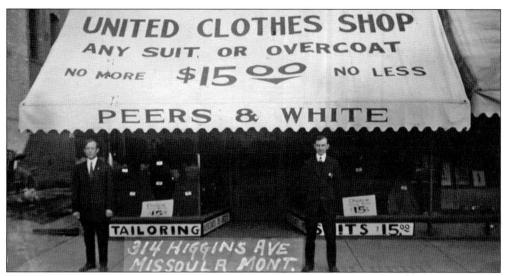

The United Clothes Shop was located at 314 North Higgins Avenue. This is now the location of Moose Creek Mercantile.

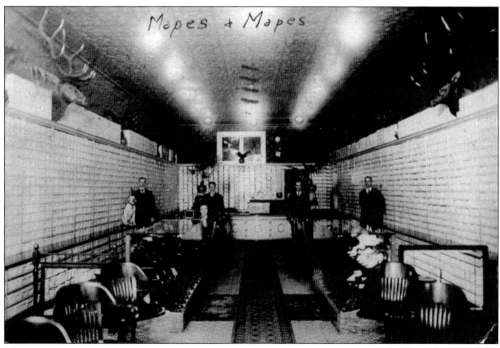

Mapes and Mapes shoe store was located at 214 North Higgins Avenue in 1910. This is now the location of Doc's Sandwich Shop.

FROM SAVING COMES HAVING.

An account in our bank is easily converted into a horn of plenty, as even small savings, regularly deposited and allowed to remain at compound interest, will in time work wonders.

Every dollar you save makes it easier to get another, as money begets money, and opportunity awaits on him who has money.

The richest man in the world began by saving his pennies. Save more and have more, and make our bank a stepping-stone to greater prosperity.

MISSOULA TRUST AND SAVINGS BANK
MISSOULA, MONTANA.

Anybody anywhere can bank with us by mail.

Several Missoula businesses, including these two financial institutions, produced postcards to promote their companies.

A MERRY CHRISTMAS AND A HAPPY NEW YEAR.

The surest road to happiness and independence is to spend less than you earn, and independence is an unfailing source of contentment.

It is the duty of everyone to prepare for the future by saving a part of their income.

Resolve to save more the coming year, and make your future full of comfort and satisfaction.

If you have not an account with us, open one at once.

Your money is safe in our bank, and it will grow and compound.

SCANDINAVIAN-AMERICAN BANK
MISSOULA, MONTANA
A. D. Stephens, Prest.: J. Dahlgren, Cashier
Any person anywhere can bank with us by mail.

In 1894, a brewery was built at the foot of Waterworks Hill that would become the Garden City Brewing Company. It stayed in business until Prohibition stopped beer production in 1919. In 1933, beer was once again legal, and the brewery reopened as Sick's Missoula Brewing Company, with Highlander as its name brand. The brewery closed in 1964 to make way for the new Interstate 90 right-of-way.

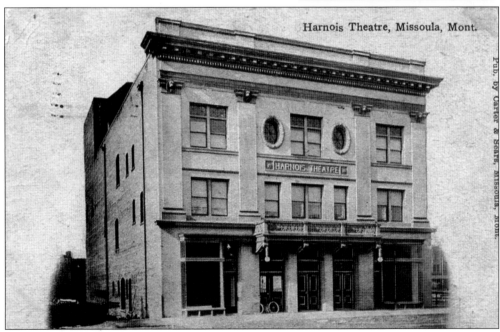

The Harnois Theater opened in 1908 and was located on East Main Street next to the old chamber of commerce building. It was one of the city's most popular theaters. Torn down in the 1960s, the building is now a parking lot. Charles A. "Uncle Charlie" Harnois was the manager.

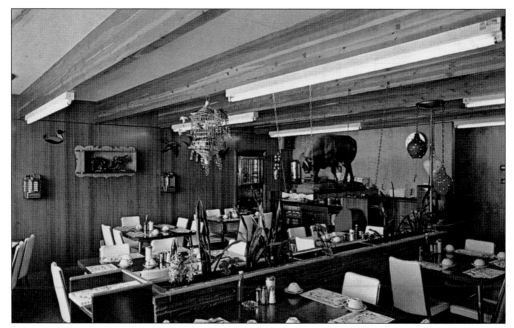

This was the interior of the 4-B's restaurant chain at 1359 West Broadway, started by Bill and Buddy Hainline in 1947 and named after them and their two children, Bill Jr. and Barbara. The chain expanded throughout Montana and New Mexico but closed down in 2007.

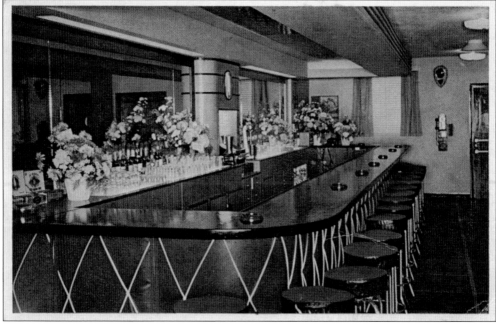

This is the interior of the popular Flame Lounge on East Main Street in downtown Missoula. It was owned and operated by George and Pasty Pramenko and family from 1946 to 1980. The building has been recently restored to its original 1890s facade and has been leased to a private club and a dance facility.

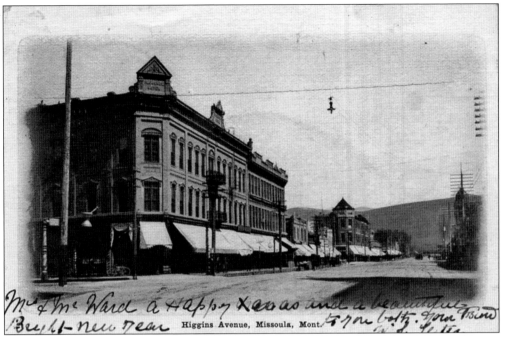

This 1905 view of North Higgins Avenue shows the Florence Hotel on the left with the Daly Block farther down the street.

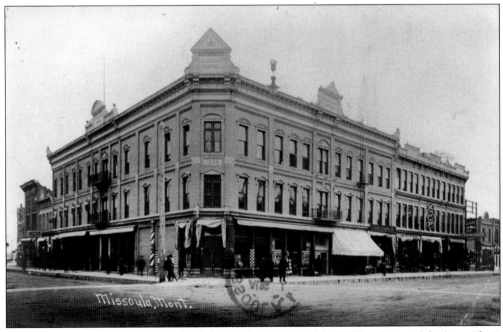

The original Florence Hotel was built by A. B. Hammond in 1888 and named for his wife. It was the premier hotel in town until it burned down in 1913. This view is from 1911.

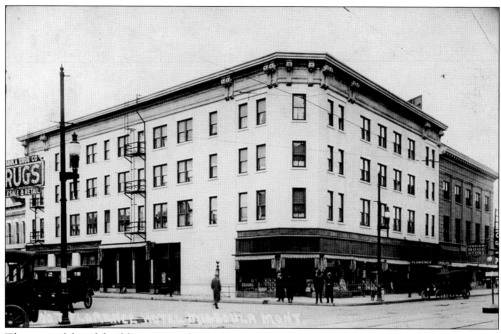

The second hotel building, a much more modern structure, was built in 1913 at the same location. It, too, would burn down in 1936.

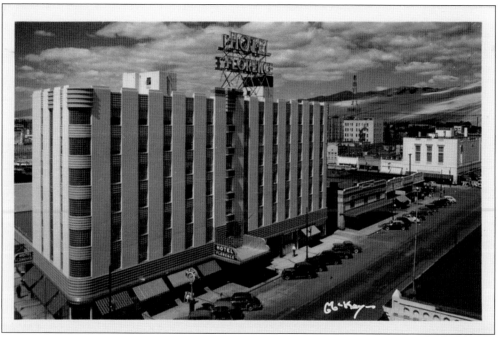

The third Florence Hotel was opened in 1941 by the Missoula Real Estate Association. The $600,000 building had seven stories, 175 rooms, a main dining room, coffee shop, cocktail lounge, banquet rooms, and several retail outlets. It would be the hub for Missoula's business and social life until it closed in 1976. Today the Florence Building is owned by the ALPS Corporation and is leased out for offices and retail stores.

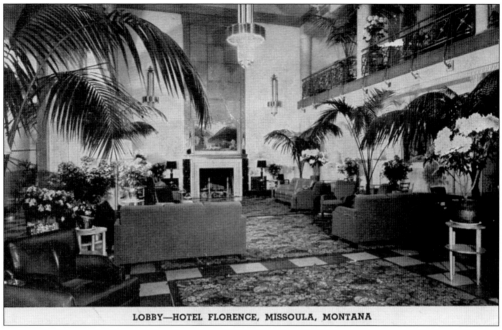

LOBBY—HOTEL FLORENCE, MISSOULA, MONTANA

The elegant lobby of the Florence Hotel has been restored to its former grandeur; it is used for social functions and the lobby for a local restaurant.

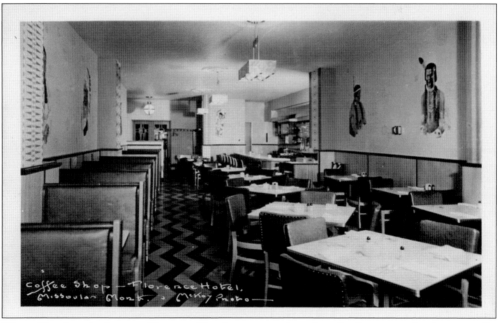

The coffee shop in the new Florence Hotel was a meeting place for downtown businessmen for many years.

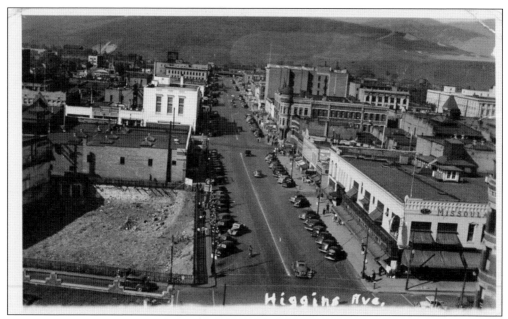

This view is interesting as it shows (on the left) the site of the Florence Hotel that burned down in 1936. The surviving Kohn Jewelry clock can be seen on the sidewalk. The real-photo postcard would have had to be taken between 1936 and 1940 as the new hotel building opened in 1941. The large white building on the left was the new Montgomery Ward store, which opened in 1935.

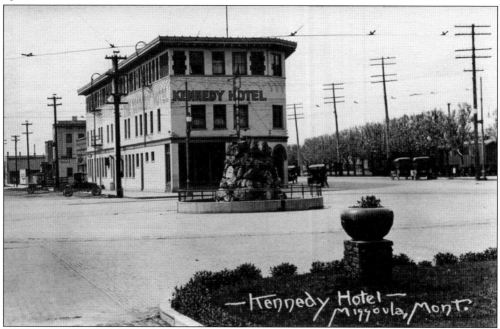

This building on Circle Square was built in 1903 opposite the Northern Pacific depot. It was first called the Grand Pacific Hotel, later the Kennedy Hotel, and finally the Park Hotel. The fountain in the front center was placed there in 1913 with large pieces of natural stone brought from the surrounding mountains.

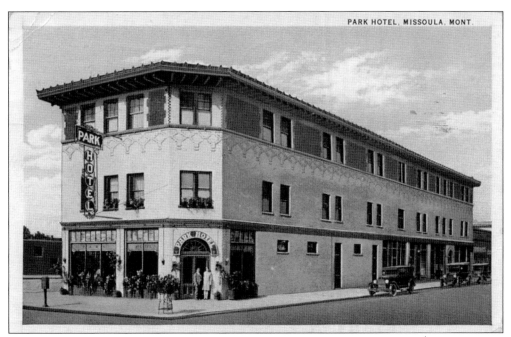

This is a 1931 view of the hotel. It was right across the square from the Northern Pacific depot and, along with other small hotels in the immediate area along Railroad Street, served the traveling public.

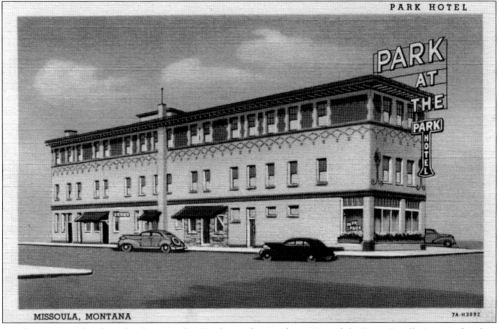

PARK AT THE PARK HOTEL

MISSOULA, MONTANA 7A-H3892

In the 1950s, the hotel advertised, "Park at the Park, Missoula's Best Bet." A popular bar was located on the ground floor. The building has now been converted to apartments and a retail store.

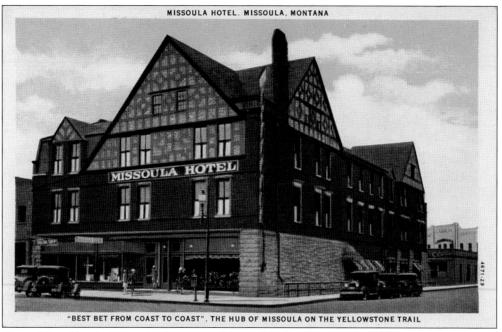

MISSOULA HOTEL, MISSOULA, MONTANA

MISSOULA HOTEL

"BEST BET FROM COAST TO COAST", THE HUB OF MISSOULA ON THE YELLOWSTONE TRAIL

One of the oldest buildings in downtown Missoula is the former Missoula Hotel, at the corner of Main and Ryman Streets. It was opened in 1891 and changed its name to the Missoula Hotel and Apartments in 1932. It has had several facade remodels through the years and is now apartments and retail space.

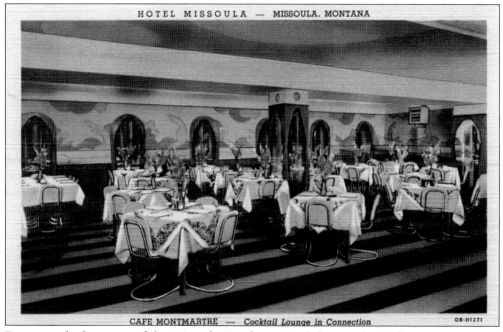

HOTEL MISSOULA — MISSOULA, MONTANA

CAFE MONTMARTRE — Cocktail Lounge in Connection

For years, the basement of the Missoula Hotel contained the popular Café Montmartre and Jungle Club.

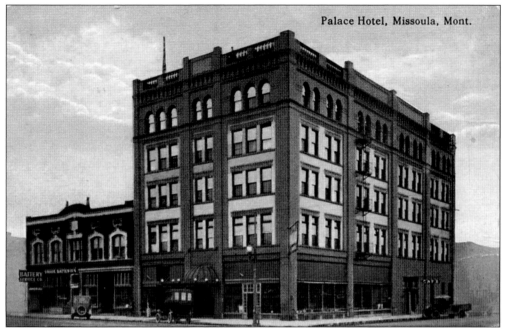

The original part of the present Palace Hotel building on West Broadway was built as the Savoy Hotel in 1909. The hotel's name was changed to the Palace in 1911. There were 125 rooms and suites with baths, telephones, running water, steam heat, electric lighting, and an elevator.

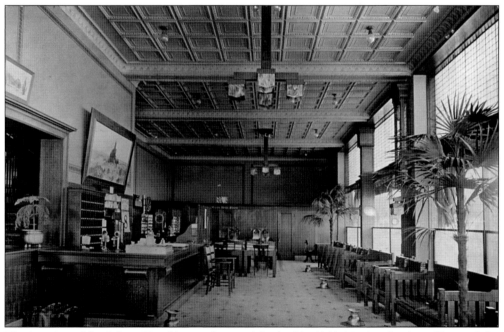

The interior of the Palace Hotel is seen here as it looked in 1911. Notice the tin ceiling and the large painting over the desk. This space is now occupied by a bar and lounge.

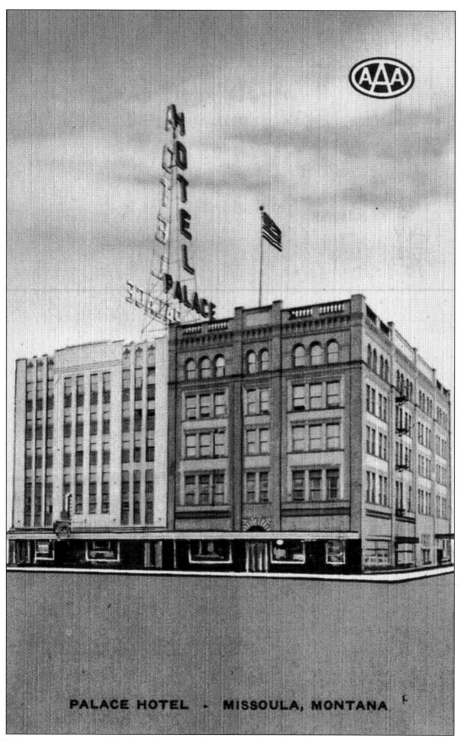

PALACE HOTEL - MISSOULA, MONTANA

In 1941, an annex was added to the east, thus expanding the hotel to the largest in downtown Missoula. The hotel closed in 1980, and today it is an apartment building with a restaurant and bar on the bottom floor.

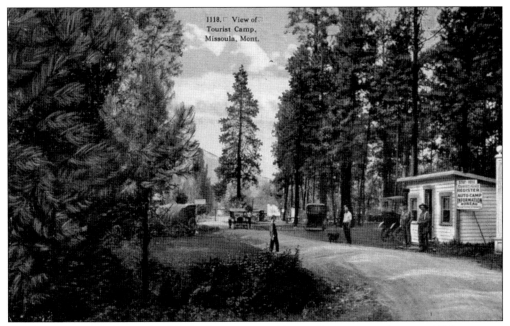

A 1920s auto camp is seen in this card; guests would actually camp out in tents. This was one of the earliest auto camps in Montana.

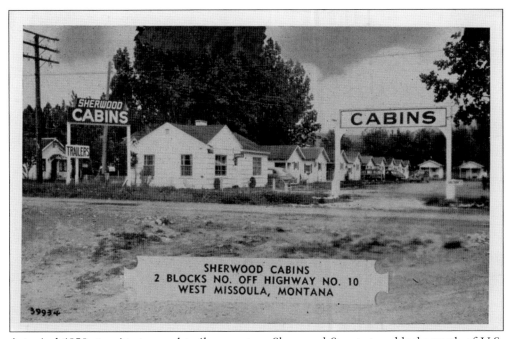

SHERWOOD CABINS
2 BLOCKS NO. OFF HIGHWAY NO. 10
WEST MISSOULA, MONTANA

A typical 1950s tourist stop and trailer court on Sherwood Street, two blocks north of U.S. Highway 10, is pictured here. There were 16 cottages with private baths, one or two rooms, and gas-equipped kitchenettes.

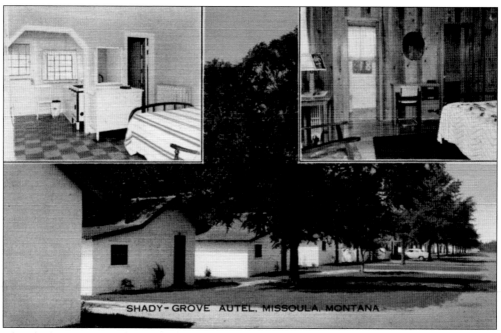

The Shady-Grove Autel was located at 1245 West Broadway near Russell Street.

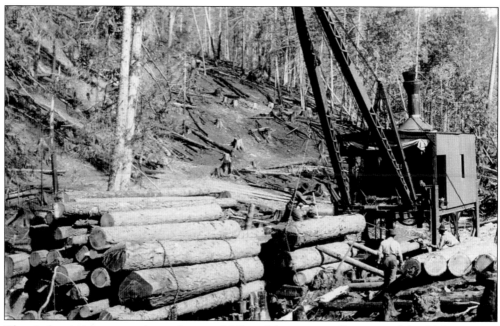

The timber industry was the mainstay of Missoula's economy for most of the 20th century. Logging operations were conducted all over western Montana to feed the many sawmills in Missoula and Bonner.

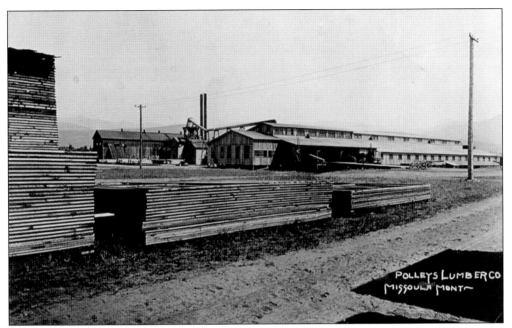

The Polleys Lumber Company was a major timber producer in the area. It had a daily capacity of production of 100,000 board feet in its sawmill and planing mill according to this 1913 card. Today all the sawmills in the Missoula area have shut down.

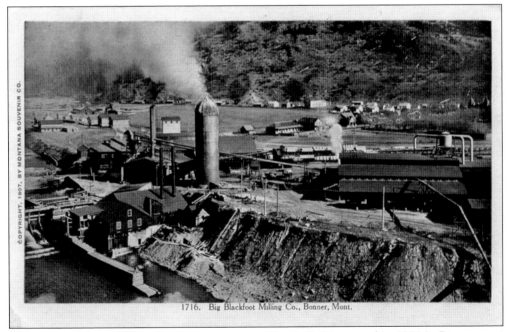

The Big Blackfoot Milling Company was opened by A. B. Hammond in 1886 in Bonner, east of Missoula. At the time, it was the largest lumber mill in the world. In 1898, Hammond sold the mill to the Anaconda Copper Mining Company, where they produced timbers for the mines in Butte and dimensional lumber. This view is from 1907.

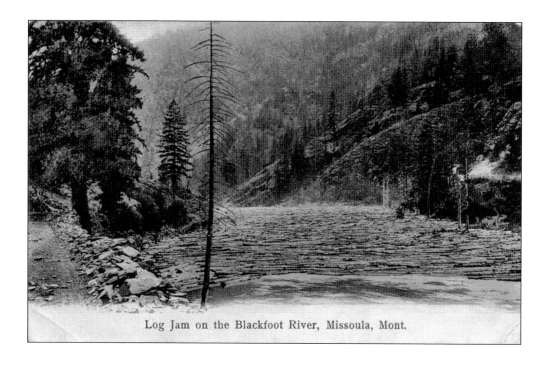

Log Jam on the Blackfoot River, Missoula, Mont.

For many years early in the 20th century, logs were floated down the Blackfoot River to the mill site at Bonner, where they were kept in the water until ready to be sawed into mine timbers and lumber.

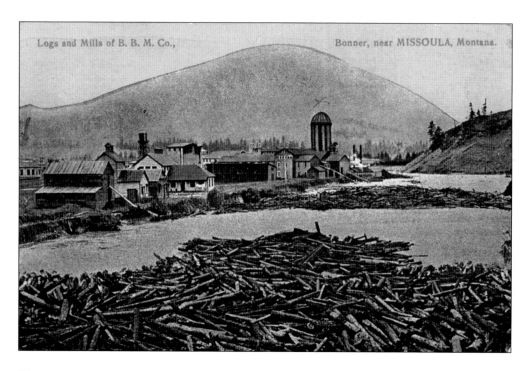

Logs and Mills of B. B. M. Co., Bonner, near MISSOULA, Montana.

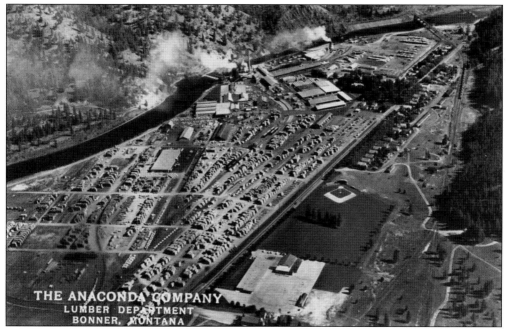

The Anaconda Forest Products Company plant at Bonner was a huge operation in this mid-century view. The entire complex closed in 2008, and the company houses along U.S. Highway 200 have been bought by a private investor. The Blackfoot River dam can be seen right behind the main mill and the small Bonner School and playground in the center bottom. In 1972, the U.S. Plywood/Champion Paper Company bought the mill and the timberlands and built the largest plywood plant in the world. Stimson Lumber Company was the last operator.

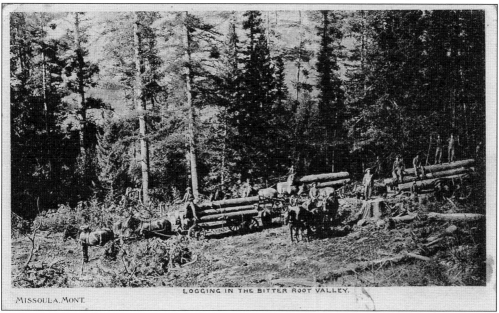

For years, the Bitterroot Valley and surrounding mountains were a major source of timber for the mills in both the Bitterroot and Missoula Valleys. This 1907 card shows that horse logging was the only way to get the logs out of the forest at the time.

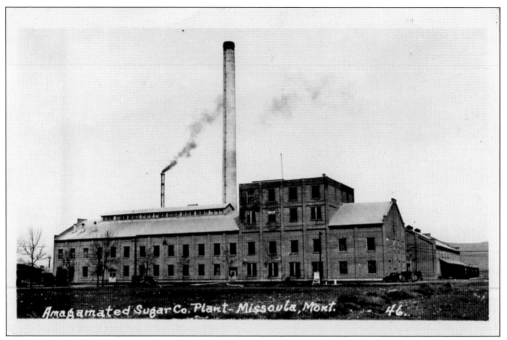

One of the Missoula area's largest agricultural products was sugar beets. This plant of the American Crystal Sugar Company, located just off present-day Reserve Street, was opened in 1928. In 1966, the plant closed and most of the buildings were torn down. Parts of two buildings still remain as office space.

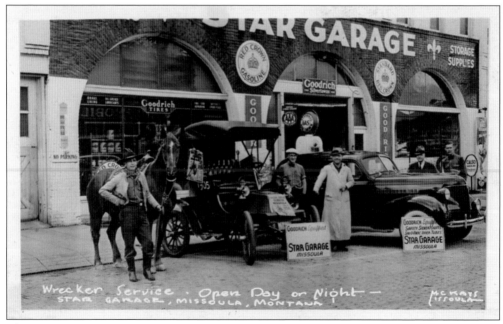

The Star Garage on West Front Street was a leading automotive shop in downtown Missoula. This view is from the late 1930s. The business lasted into the 1970s, but the top story was then taken off and the building converted to office space for an insurance company.

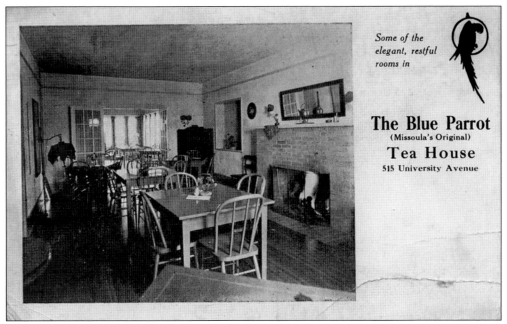

Some of the elegant, restful rooms in

The Blue Parrot
(Missoula's Original)
Tea House
515 University Avenue

The Blue Parrot Tea House was located at 515 University Avenue in the University District. The site was later a dress shop and a private residence.

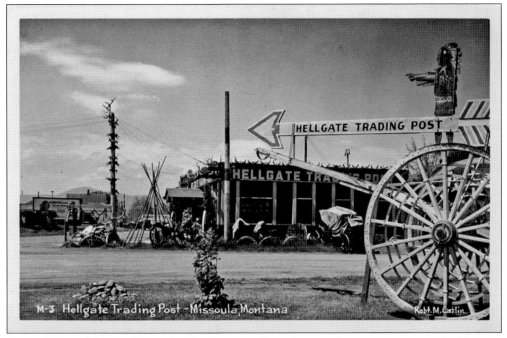

M-3 Hellgate Trading Post - Missoula Montana Robt. M. Catlin

One of Missoula's most interesting businesses and tourist stops for many years was the Hellgate Trading Post, located at 1102 West Broadway. The store lasted into the 1970s.

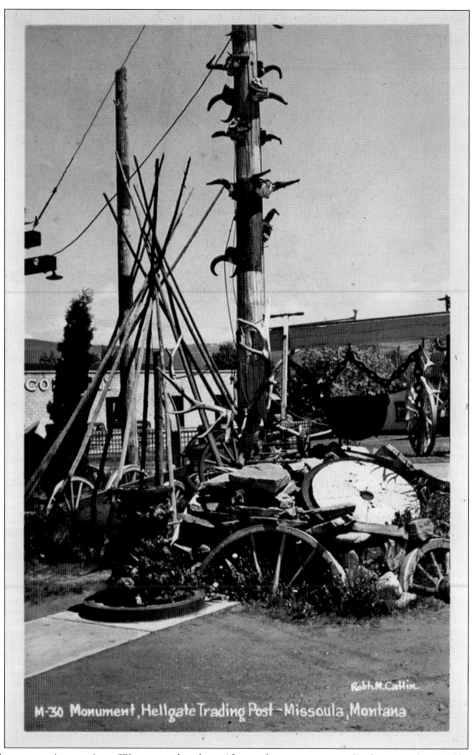

M-30 Monument, Hellgate Trading Post - Missoula, Montana

These are interesting Western–related artifacts that were on display at the Hellgate Trading Post.

Seven

THE UNIVERSITY
OF MONTANA

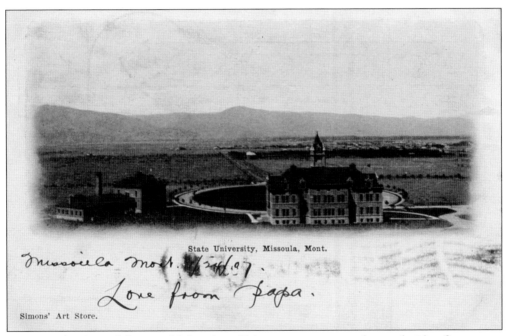

State University, Missoula, Mont.

Simons' Art Store.

A very early view of the new University of Montana campus on the south side of town was taken before 1903. The oldest building was Science Hall on the left, since torn down. Main Hall, or University Hall as it was first called, is in the center. Both buildings opened in 1898. No other buildings were on campus at the time. The card is older than the post date of 1907.

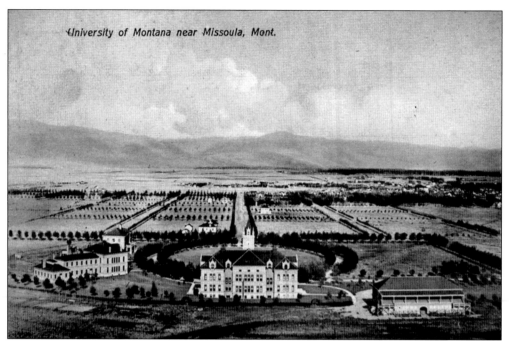

When this card was printed about 1907, the university had expanded around the oval to include Women's Hall on the left and the Men's Gym on the right. The University District stretching to the west was virtually empty at this time.

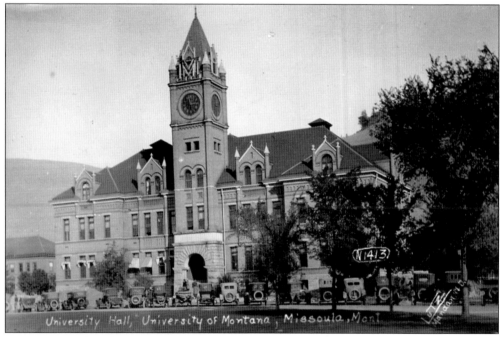

The campus's oldest remaining building, now called Main Hall, was built at a cost of $50,000 and dedicated in early 1899, though it was completed in 1898. It now houses the university's administration offices. A. J. Gibson designed it along with Science Hall and three other buildings on campus.

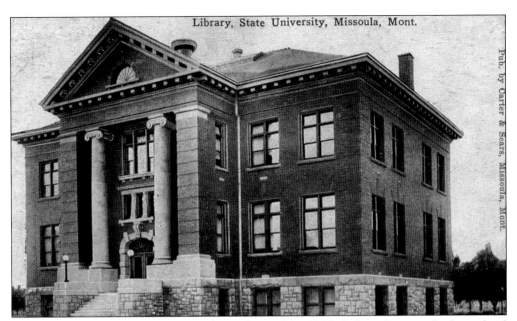

The university's first library was built on the oval in 1908. It later became the law school and the home of the psychology school, and it now houses the departments of environmental studies and social work. It is now called Rankin Hall after UM graduate Jeanette Rankin (1880–1973), a Missoula native who was the first female elected "congressman" in the country and a noted peace activist who voted against America's participation in both world wars.

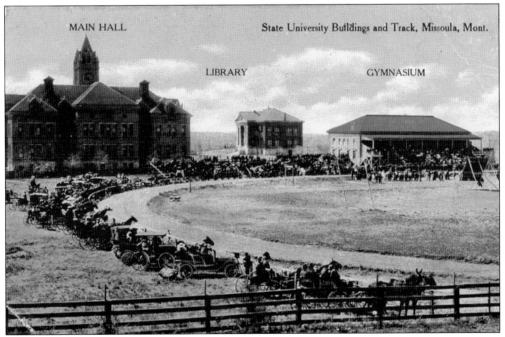

MAIN HALL State University Buildings and Track, Missoula, Mont.

LIBRARY GYMNASIUM

Here is an early-1900s football game, when cars or horse-drawn vehicles could park by the oval field to watch the game. The back of the Men's Gym served as the grandstand. The annual Montana Interscholastic Tournament track meet was held here starting in 1904.

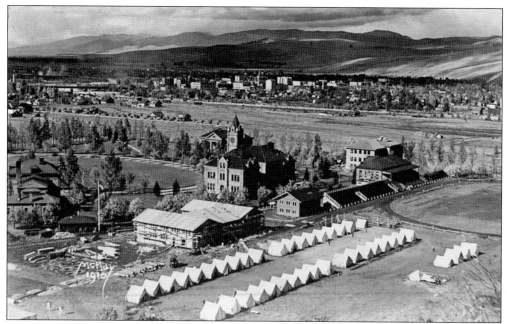

During World War I, members of the Student Army Training Corps were quartered for a time in tents on the baseball field. The program was established in October 1917 and disbanded in December 1918. Simpkins Hall on the left is being constructed as a barracks. After the war, the building housed journalism, drama, and forestry classes before being torn down in 1960.

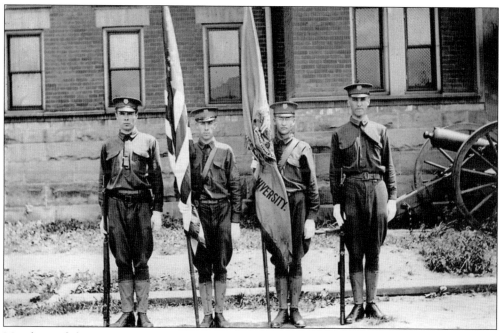

Members of the Student Army Training Corps, which was active on campus in 1917–1918, pose for a picture. Notice the Civil War–era cannon in the background.

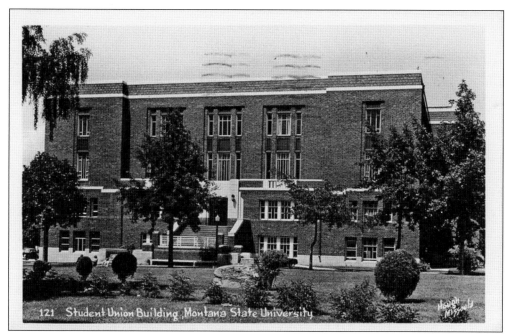

121 Student Union Building, Montana State University

The former Student Union Building was built in the modern art deco style in 1935, partially as a Public Works Administration project. The building served the students until the 1950s, then became the Women's Center, and is now the University Theater and Art Department.

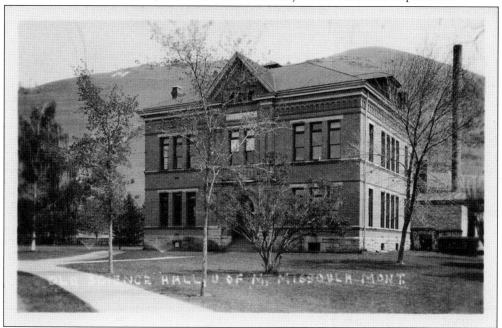

SCIENCE HALL, U OF M, MISSOULA MONT.

Science Hall was actually the oldest building on campus, opening before Main Hall in 1898. For years, it housed the chemistry, biology, and physics departments. The engineering school was also in this building until it was moved to Montana State College. The building was eventually named the Venture Center housing innovative programs but was torn down in 1983. The Davidson Honors College was built on the site.

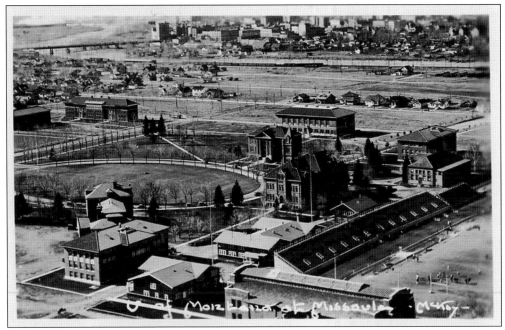

This campus view was taken in the early 1930s in the fall or winter. Notice the vehicles around the oval, which was open to traffic at the time. The area between downtown and the campus is beginning to fill in.

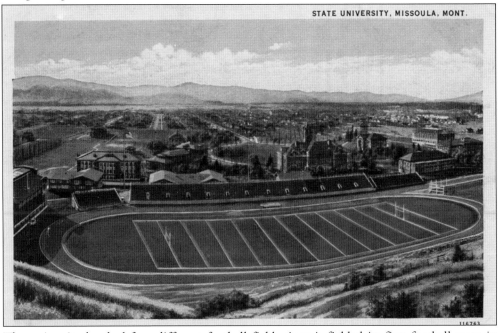

The university has had four different football fields since it fielded its first football team in 1897. This view is of the second field, built just south of the first one and named after Paul Dornblaser, a former football player killed in World War I. In 1968, the field was moved to the corner of South and Higgins Avenues, and the new library and university center would be built on the site. The present Washington-Grizzly stadium was opened in 1986.

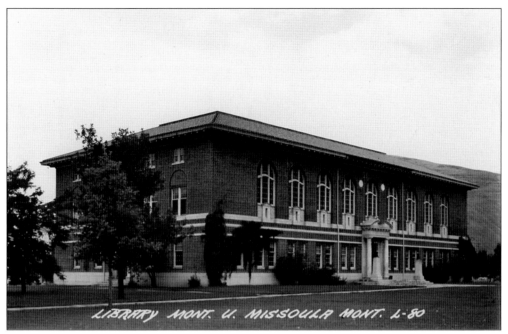

The second library was built in the Renaissance Revival style in 1922 and served in that function until 1974, when the present library was built. An addition was constructed on the back in 1955. This is now the Social Sciences Building.

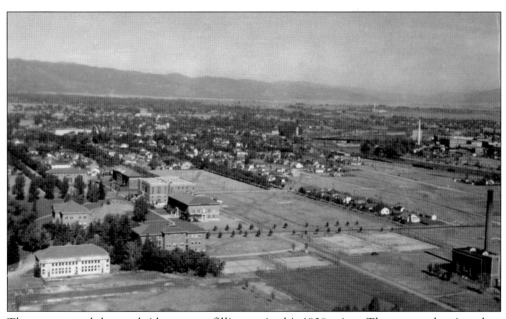

The campus and the southside area are filling up in this 1930s view. The campus heating plant is in the lower right. Buildings on the left include the natural science building, Women's Gym, Student Union, the library, and the law school. The downtown area is at the extreme right.

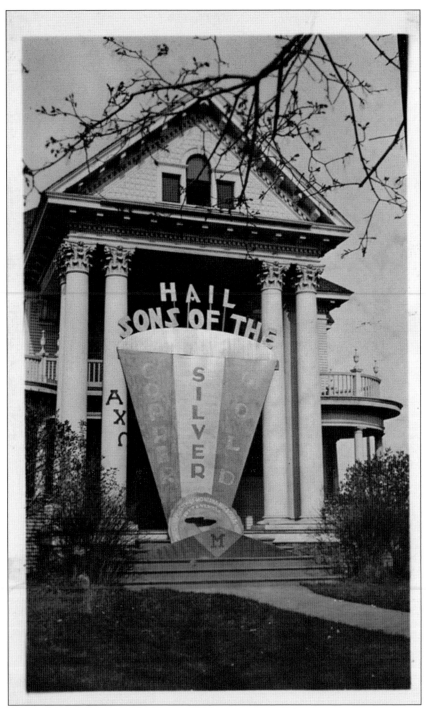

This A. J. Gibson–designed home (the Peterson mansion), originally the home of Gustave Peterson, was located at 817 Gerald Avenue in the University District. Peterson was a local druggist and county commissioner. Built in 1903, it eventually became the home of the Alpha Chi Omega fraternity. It was moved in 1979 to make way for an addition to Hellgate High School and placed at 823 39th Street. Today it is the Gibson Mansion Bed and Breakfast.

Eight

MISSOULA IN BLACK AND WHITE

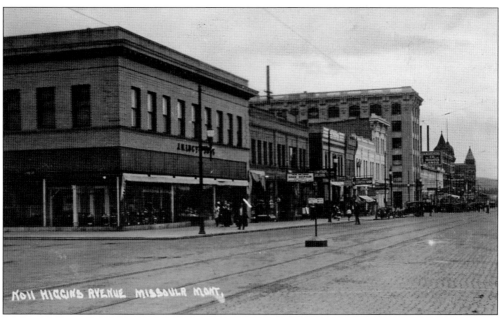

The east side of North Higgins Avenue at the corner of Pine Street was close to the NP depot. The J. M. Lucy and Sons Furniture Store, designed by A.J. Gibson, was built in 1909. At one time, the business also included a funeral parlor. The card is dated 1919. Notice the direction sign placed in the middle of the street between the streetcar tracks.

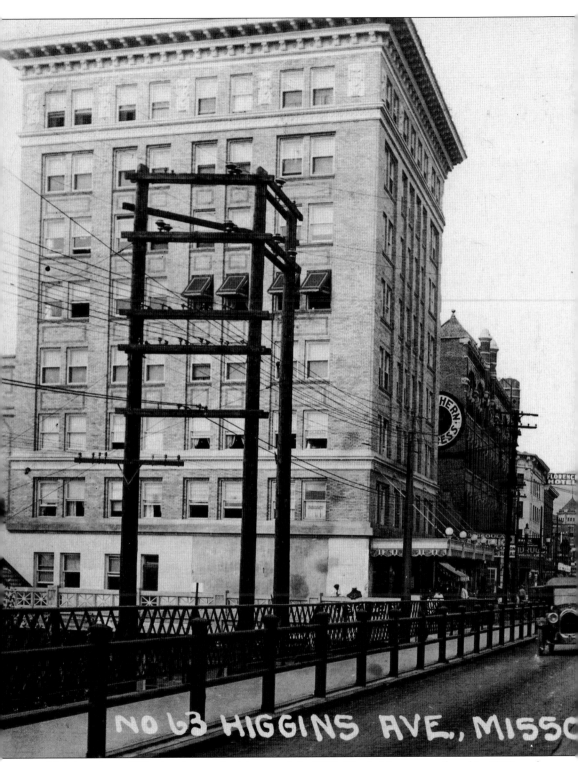

NO 63 HIGGINS AVE., MISSO

This is a view of Higgins Avenue looking north in 1923. The bridge was replaced in 1962, and the First National Bank building was demolished the same year. Missoula was first known as

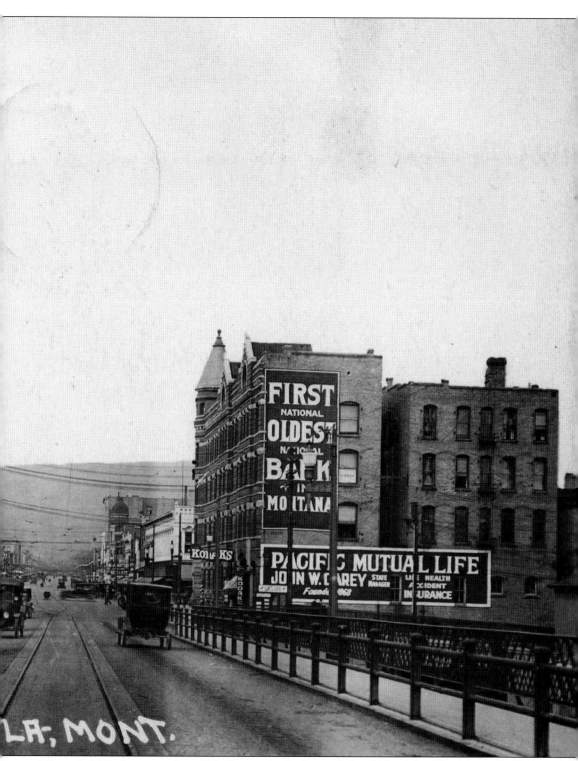

FIRST
NATIONAL
OLDEST
NATIONAL
BANK
IN
MONTANA

KODAKS

PACIFIC MUTUAL LIFE
JOHN W. C AREY STATE LIFE HEALTH
 MANAGER ACCIDENT
Founded 1868 INSURANCE

LA, MONT.

Missoula Mills because of a mill built at a site in front of the old bank building in 1864. This mill was torn down in 1912.

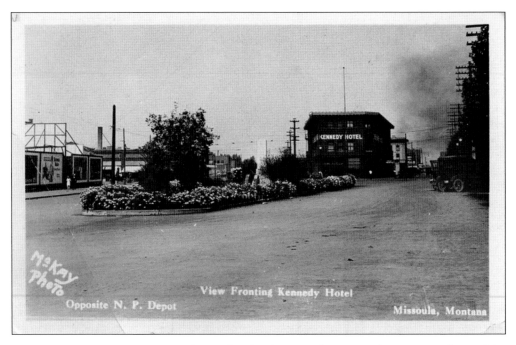

View Fronting Kennedy Hotel

Opposite N. P. Depot

Missoula, Montana

For many years, a monument to John Mullan has been in place at Circle Square, in front of the NP depot. Another similar monument once placed at the corner of West Main and Orange Streets has now been relocated to Milltown. Mullan was an army officer who was charged with the construction of a road connecting Fort Benton, Montana, and Walla Walla, Washington Territory, in the 1860s. The Kennedy Hotel was later called the Park Hotel. The old NP steam engine now sits on this site on Circle Square, and a popular farmers' market is held here during the spring, summer, and fall.

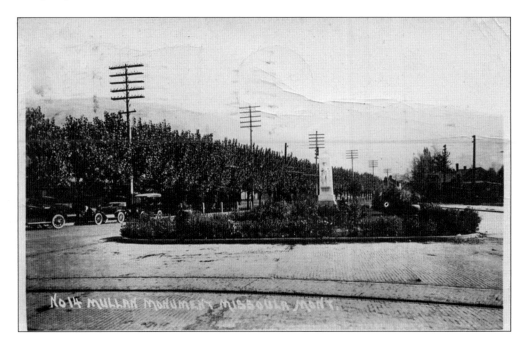

No 14 MULLAN MONUMENT MISSOULA MONT.

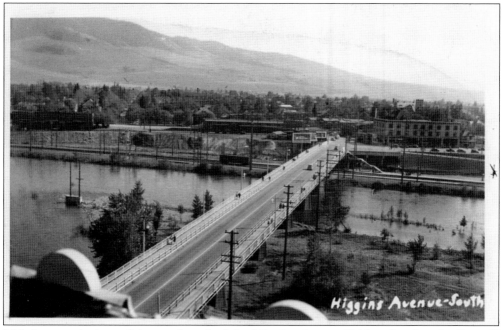

This is a good view of the south end of the Higgins Avenue Bridge showing the Penwell Building on the right and the Milwaukee Road freight warehouses in the center. The view was taken from the top of the Wilma Building.

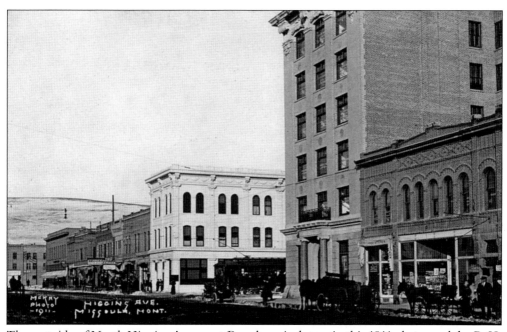

The east side of North Higgins Avenue at Broadway is shown in this 1911 photograph by R.H. McKay. A streetcar is in view, but most vehicles were still horse drawn at this time. The avenue would be brick paved the next year.

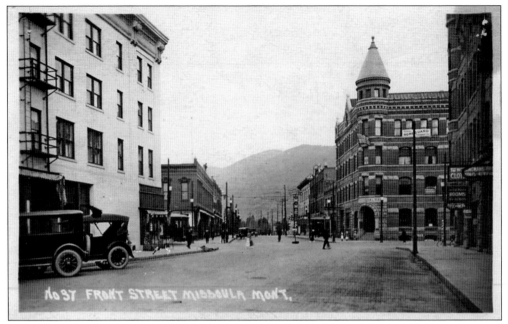

This 1923 view shows Front Street looking east. The left building is the second Florence Hotel with the Missoula Mercantile across the street. The First National Bank is on the opposite corner, and the building at the end of the block has a sign for the Mercantile's carpet and furniture departments.

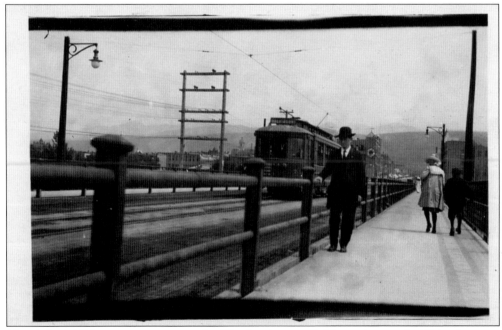

The Daly Addition streetcar crosses the Higgins Avenue Bridge going south. This view was probably taken after 1912, as Missoula's original mill appears to be gone at the extreme right.

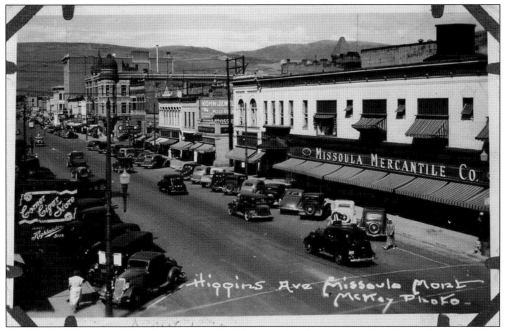

A mid-1930s view of Higgins Avenue, looking north, shows a great variety of automobiles. The streetcars were discontinued in 1932, and buses took their place.

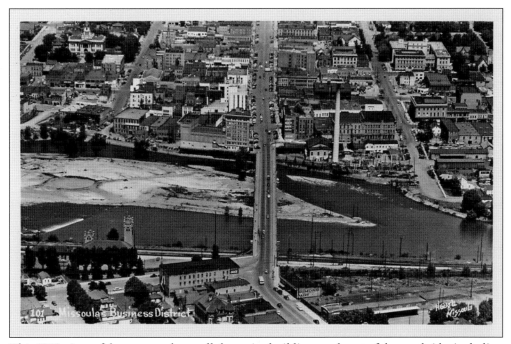

This 1950 view of downtown shows all the major buildings and part of the southside, including the area at the lower right, which was at one time the Milwaukee Road's freight warehouses. This is now the site of the *Missoulian* building. The river channel was changed along with a new bridge in 1962, and the present-day Caras Park area was formed.

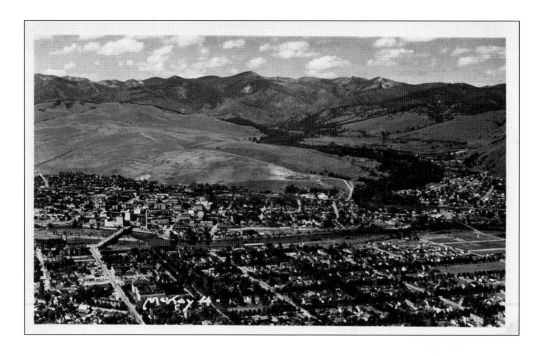

Aerial views of Missoula in the 1950s are shown here, with the top view looking north. The Clark Fork River separates the north and south parts of town. The large building in the lower left is Hellgate High School. The river channel along the Wilma Building was changed in 1962, filling in the area to form a park. The bottom view is another of the Missoula Valley looking north. A lot of the southside at the bottom left had not been developed yet.

M-9 Missoula, Montana Robt. N Catlin

Nine

PEOPLE, PLACES, AND THINGS

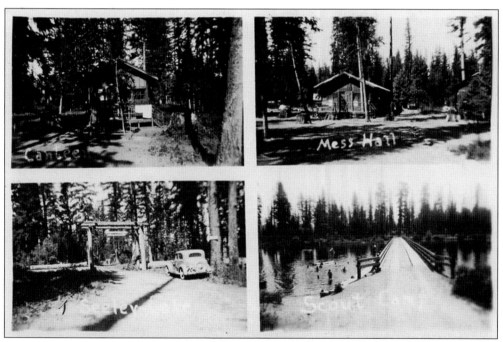

Views of Camp Paxson, named for artist Edgar S. Paxson, is located on the west shore of Seeley Lake, 50 miles north of Missoula. The town and lake are a major playground for Missoula residents. The camp is a complex of 20 log buildings that demonstrate exceptional architectural values—including craftsmanship, materials, and design—built by the CCC and WPA in 1939–1940. It was used by the Boy Scouts of America, Camp Fire Council, and the U.S. Forest Service smokejumpers during World War II. It is now leased by the Missoula Children's Theater.

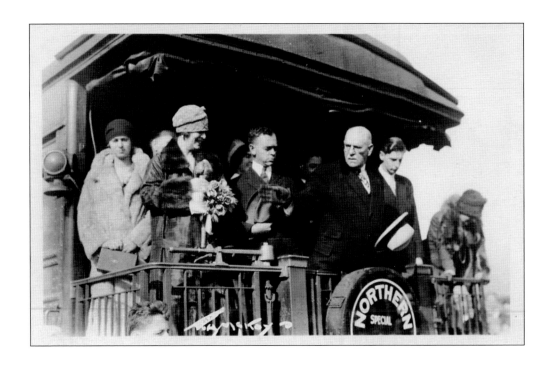

In 1926, former Queen Maria of Romania made a stop in Missoula on her nationwide tour of the country to gain support and money for the restoration of the country's monarchy in her homeland. She was the wife of King Carol and the granddaughter of Queen Victoria of Great Britain.

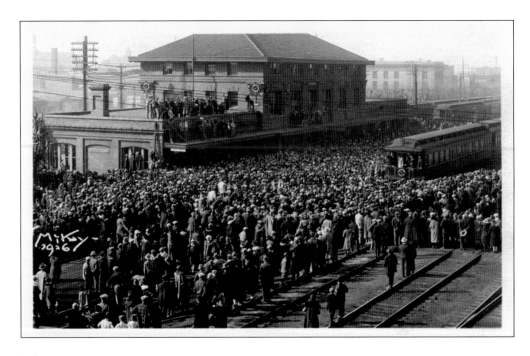

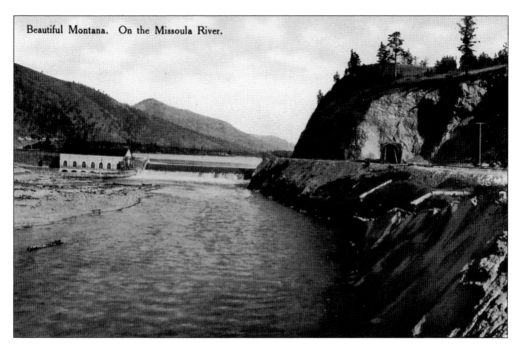

Beautiful Montana. On the Missoula River.

The Milltown Dam, also known as Clark's Power Plant, on the Missoula (Clark Fork) River, was named after W. A. Clark of Butte. He had the dam and powerhouse built in 1908 to provide power for his Bonner sawmill and Missoula-based power companies. Huge generators were placed in the powerhouse. During the 1908 flood, there was a concern that the dam would be breached, but fortunately it held. The powerhouse was torn down in 2007 and the dam removed in 2008 so the Clark Fork and Blackfoot Rivers would be free-flowing again for the first time in 100 years.

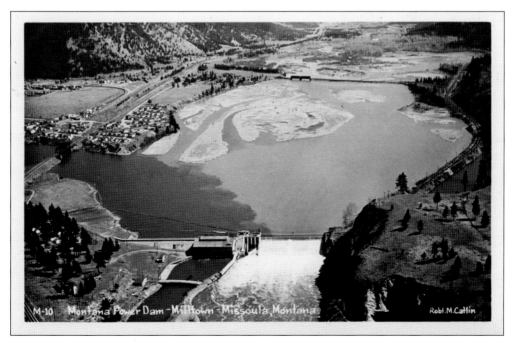

M-10 Montana Power Dam - Milltown - Missoula Montana Robt.M.Catlin

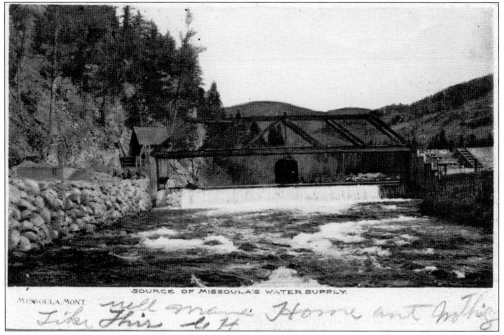

SOURCE OF MISSOULA'S WATER SUPPLY.

MISSOULA, MONT.

Rattlesnake Creek was Missoula's water supply when this dam was constructed in the early 1900s. It was reconstructed in the 1920s. The dam is still there but was last used as part of the city's water supply in 1983.

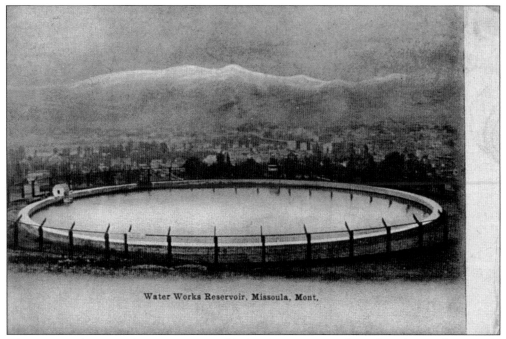

Water Works Reservoir, Missoula, Mont.

The waterworks reservoir was constructed in 1902 on Waterworks Hill in the north Missoula hills to provide a consistent supply of water to the city. In 1971, it was first covered by a rubber fabric and by an aluminum cover in 1979.

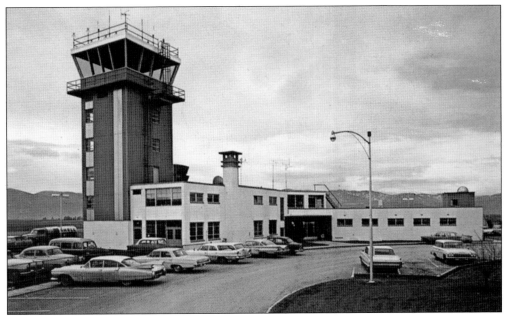

This 1960s view of the Missoula County Airport terminal looks entirely different than the building today. The airport, which is located west of town, was a 1939 WPA project and opened in June 1941. The terminal has been remodeled several times in the past few decades. Today the airport is home to several airlines, an air tanker firefighting business, the Museum of Mountain Flying, and other aviation services.

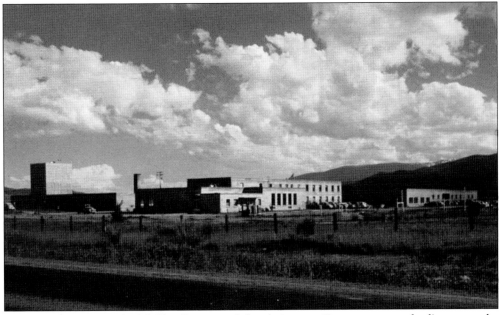

In 1954, the present Aerial Fire Depot and Smokejumper Base was opened adjacent to the present airport. Pres. Dwight Eisenhower dedicated the facility before the largest crowd to assemble in Missoula up to that time. The facility has grown through the years, and the Fire Sciences Laboratory and Missoula Technology and Development Center are now located adjacent to it.

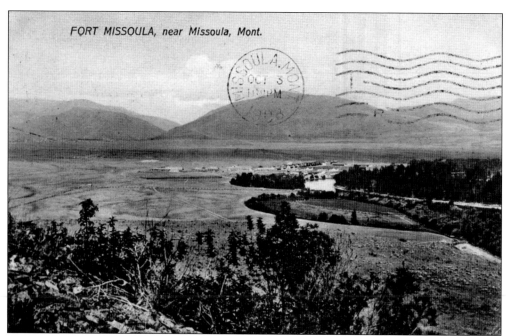

FORT MISSOULA, near Missoula, Mont.

Fort Missoula was established in 1877 as a defense against the Nez Percé Indians who roamed in the area. Capt. C. C. Rawn occupied the open fort with units of the 7th Infantry. The fort has been the home to various military units off and on ever since and at present has been mostly divided off for various government and private purposes. In the next few years, the military will move off-site for the first time since 1877.

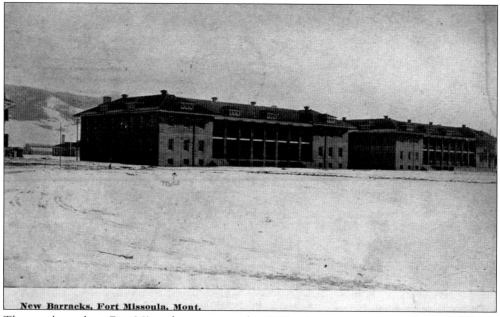

New Barracks, Fort Missoula, Mont.

The new barracks at Fort Missoula were opened in 1911 to house army troops. Other buildings, including Officers' Row and Heritage Hall, now owned by the Northern Rockies Heritage Center, were also built at the same time. The right barracks is now U.S. Forest Service offices, and the left is occupied by the U.S. Army Reserves.

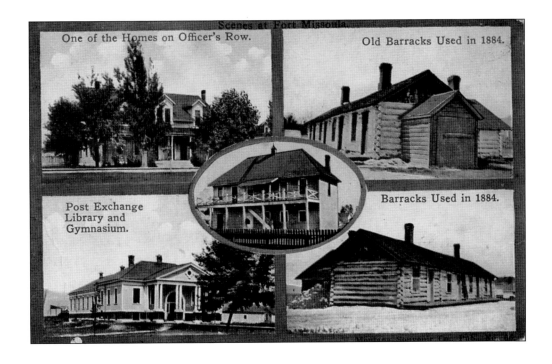

Two postcards of Fort Missoula from 1914 are shown. There are two original buildings left from the original 1877 fort—the NCO quarters and the powder magazine. Officer's Row and the post exchange are now part of the Northern Rockies Heritage Center.

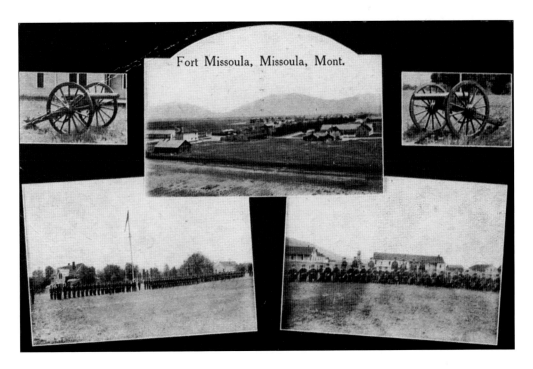

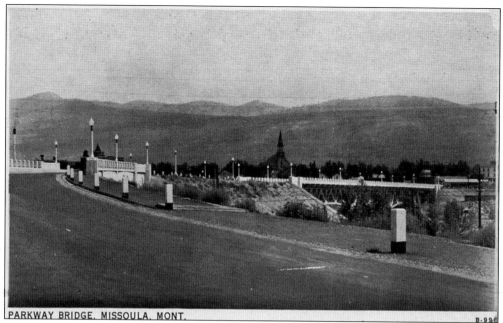

PARKWAY BRIDGE, MISSOULA, MONT. B-996

The Parkway Bridge, now the Orange Street Bridge, was built in 1937 as a Works Progress Administration project. It served the community until being replaced in 2002. The St. Francis Xavier Church can be seen in the middle against the backdrop of the North Hills.

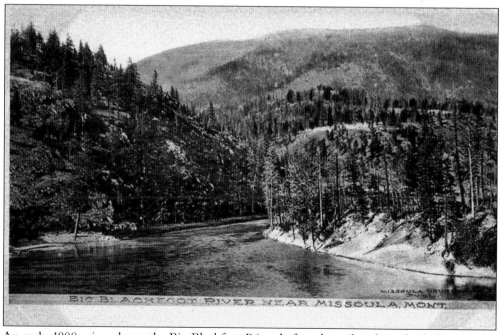

BIG BLACKFOOT RIVER NEAR MISSOULA, MONT.

An early-1900s view shows the Big Blackfoot River before the railroad was built through the valley. Today a modern highway winds through the valley leading to the Seeley Lake–Swan Highway or on to Lincoln and Great Falls. The river is a very popular recreational area in the summer. The Missoula Drug Company produced many local views in the early 1900s.

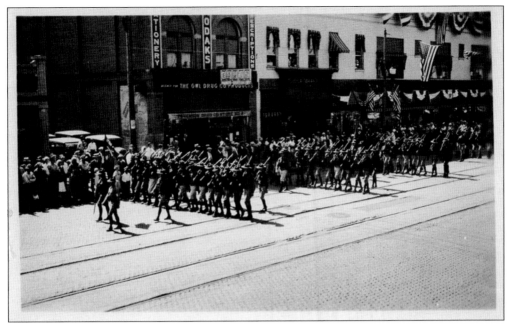

Members of the Civilian Military Training Program march down Higgins Avenue by the Missoula Mercantile in the 1920s. This was a program at Fort Missoula to give military training to civilians of the area and was run by U.S. Army troops at the fort. The Owl Drug Store was absorbed into the Missoula Mercantile store, which is now Macy's Department Store.

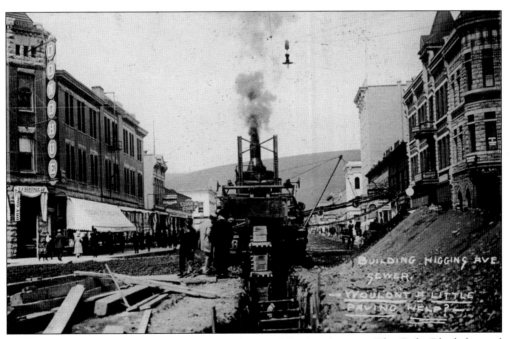

This pre-1912 view shows sewer construction on Higgins Avenue. The Daly Block housed the D. J. Donohue Company. On the right is the Higgins Block. The avenue was bricked over in 1912.

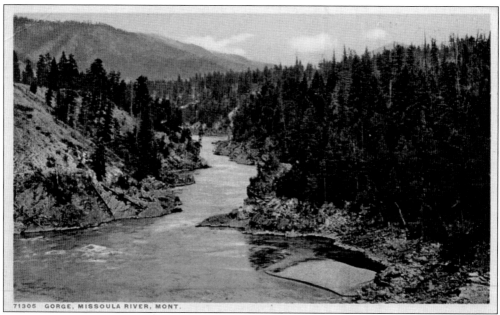

71305 GORGE, MISSOULA RIVER, MONT.

This early view of the Alberton Gorge on the Clark Fork River west of Missoula is a "Phostint" card published by the Detroit Publishing Company in the early 1900s. The cards were all hand-colored and printed in Germany and were very popular throughout the country. The gorge is a very popular boating area in the summer months.

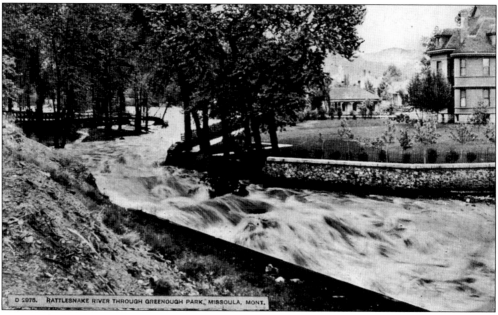

D 2975. RATTLESNAKE RIVER THROUGH GREENOUGH PARK, MISSOULA, MONT.

Mrs. Tennessee Greenough donated land in the lower Rattlesnake Valley for the present Greenough Park in 1902. The Greenough Mansion can be seen at the right along Rattlesnake Creek. It was built by Thomas Greenough in 1894 and moved, in three parts, up to the Farviews area in 1966 to make way for Interstate 90 construction. The mansion became a restaurant and golf course clubhouse. In 1992, a bolt of lightning struck the mansion and burned it to the ground. Note that the card calls the creek a river.

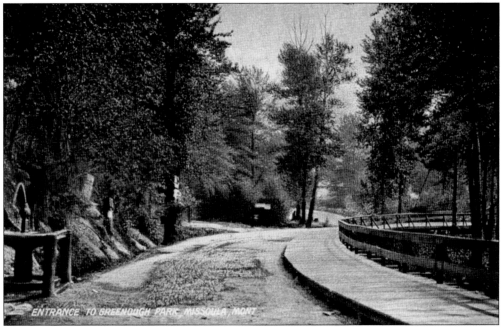

The entrance to Greenough Park is in the lower Rattlesnake area. Notice the water fountain on the left. For years, a bear was on display in a cage at the park.

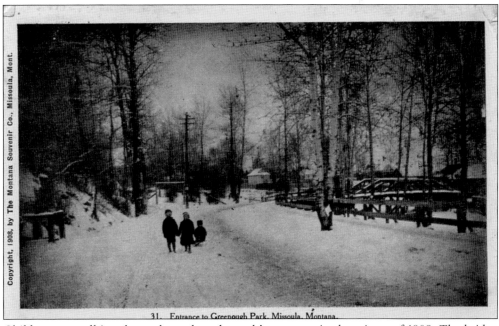

Children are walking down the path at the park's entrance in the winter of 1908. The bridge across Rattlesnake Creek is on the right.

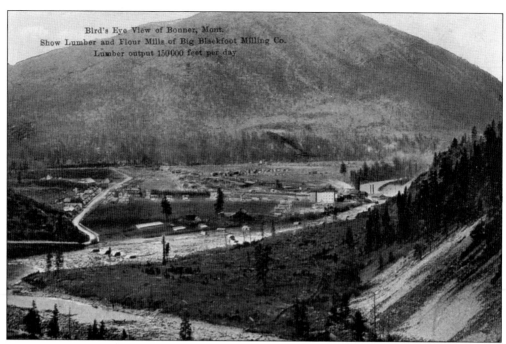

This early-1900s view of the Bonner area was actually printed backwards as can be determined by the flow of the rivers. This was not an uncommon occurrence with early postcard printers.

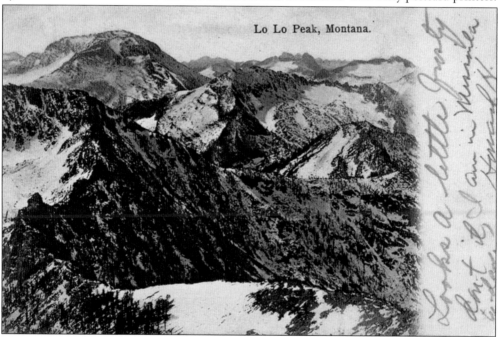

Lolo Peak is the predominant natural feature just south of Missoula. Its elevation is 9,139 feet. The peak is the boundary for the vast Selway-Bitterroot Wilderness Area that stretches into Idaho. In recent years, the peak and surrounding area have been the topic of controversy over a potential large ski area development on its eastern slopes. The area is popular for hikers and backcountry skiers.

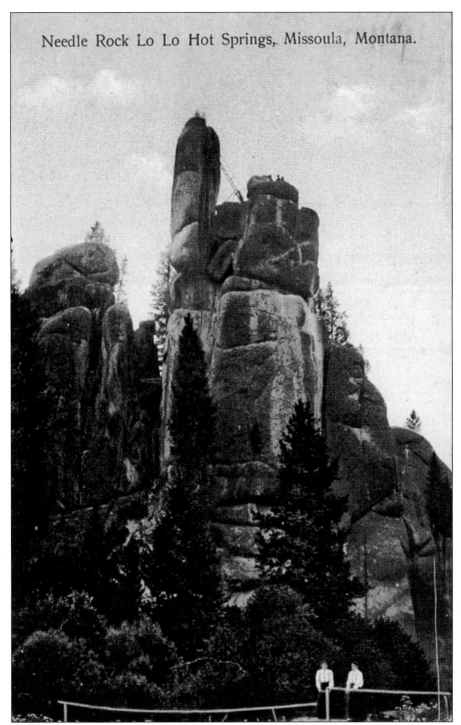

Needle Rock Lo Lo Hot Springs, Missoula, Montana.

Lolo Hot Springs, 35 miles southwest of Missoula, is noted for its unusual granite rock outcroppings. Long before Lewis and Clark passed through the area, Native Americans used the springs as a meeting place and bathing spot. The first hotel was built about 1900 and the first swimming pool in 1918. Today the springs are a popular year-round resort.

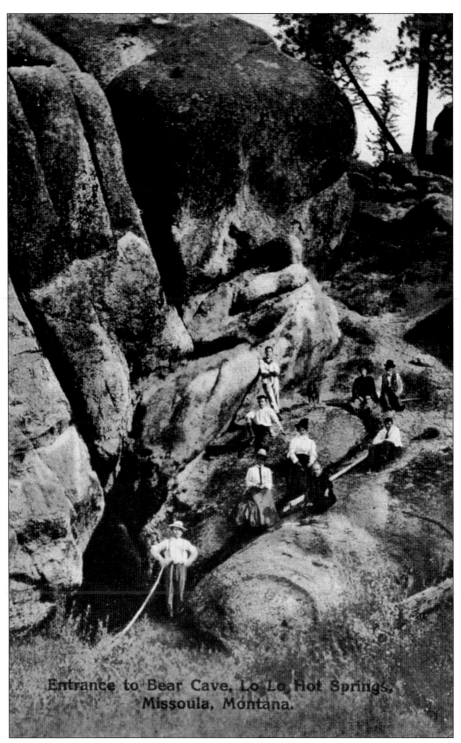

Entrance to Bear Cave, Lo Lo Hot Springs, Missoula, Montana.

Visitors are seated at the entrance to Bear Cave at the hot springs in this 1909 view. The long dresses and long-sleeved blouses must have been uncomfortable in this outdoor setting, especially at the height of the summer.

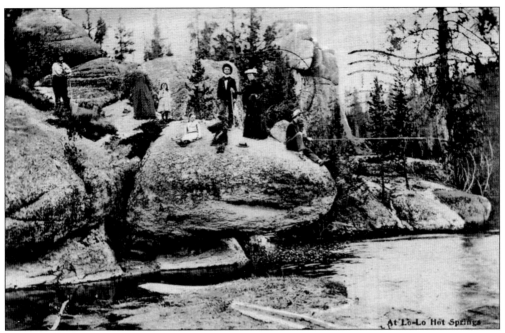

More visitors stand on the large granite rocks at the springs in this 1908 view.

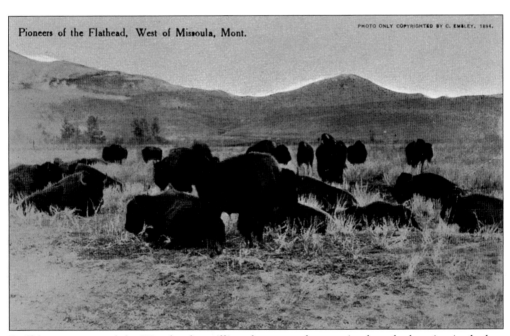

Buffalo once roamed the West by the millions but were almost wiped out by hunting in the late 1800s. They have made a comeback and can be found in many preserves and national parks in the West, including around Missoula. This view says the photograph was copyrighted in 1894. In 1908, at the request of Pres. Theodore Roosevelt, Congress established a buffalo and wild game refuge 50 miles north of Missoula on the Flathead Indian Reservation.

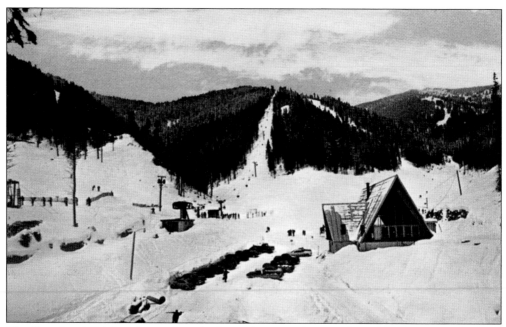

The Snowbowl Ski Area is seen here in the mid 1960s. The area, located 11 miles northwest of Missoula, was moved over from the adjacent TV Mountain in 1961, and the area's first chairlift was opened in 1962. Since then, the area has greatly expanded with a new upper chairlift, improved road, a bar, overnight lodging, and many new runs. A future expansion has been proposed on the old TV Mountain runs.

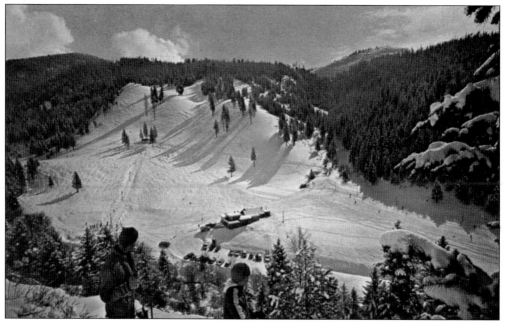

Marshall Mountain was a small family-oriented ski area five miles to the northeast of Missoula. People had skied in the Marshall Bowl since the 1930s, and the first rope tow was installed about 1950. In 1955, Si and Velma Green bought the area and operated it until selling it in 1983. Several people owned the area until it finally closed in 2002.

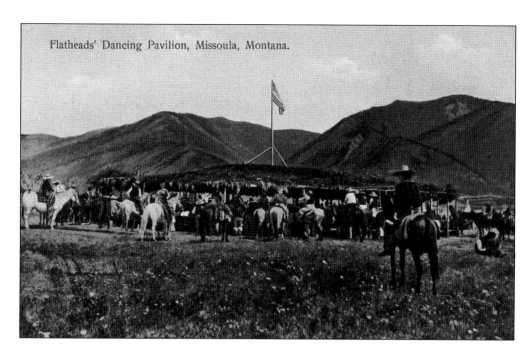
Flatheads' Dancing Pavilion, Missoula, Montana.

The Flathead Indian Reservation is adjacent to Missoula's northern boundary. It was created by the 1855 Treaty of Hellgate and now covers 1.3 million acres, though in 1910, the land was opened up for purchase by non–Native Americans. The reservation is home to the Bitterroot, Salish, Kootenai, and Pend d'Oreille tribes, all now under the name of the Confederated Salish and Kootenai Tribes of the Flathead Nation. Even in the 1940s, tribal members would camp out for ceremonies in the Missoula Valley.

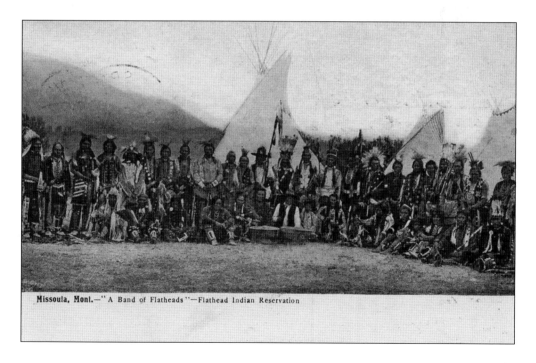
Missoula, Mont.—"A Band of Flatheads"—Flathead Indian Reservation

Missoula Mont. 8/24/06

I received your postal yesterday and will send one of my own manufacture in return. Say you had ought to have been here tonight there was a German play and it was all in Dutch, so you would have been strictly in it. Barney and I took it in. Lawrence

This 1906 real–photo postcard shows a drill team, perhaps of policemen or firemen, on Higgins Avenue in front of the D. J. Donohue Store.

BIBLIOGRAPHY

Cohen, Stan. Missoula County Images. Missoula, MT: Pictorial Histories Publishing Company, Inc., 1982.

———. Missoula County Images, Vol 2. Missoula, MT: Pictorial Histories Publishing Company, Inc., 1993.

——— and Don Miller. The University of Montana: A Pictorial History, Revised Edition. Missoula, MT: Pictorial Histories Publishing Company, Inc., 2004.

——— and Sandra Fisher. Purple & Gold: A 60-Year History of Missoula County High School, 1905–1965. Missoula, MT: Pictorial Histories Publishing Company, Inc., 2005.

Koelbel, Lenora, with Stan Cohen. Missoula the Way It Was: A Portrait of an Early Western Town, Revised Edition. Missoula, MT: Pictorial Histories Publishing Company, Inc., 2004.

Mathews, Allan James. A Guide to Historic Missoula, Montana Mainstreets, Vol. 6. Helena, MT: Montana Historical Society Press, 2002.

The Missoulian. Lasting Impressions: A Pictorial History of Missoula. Missoula, MT: Lee Newspapers, 1998.

ACROSS AMERICA, PEOPLE ARE DISCOVERING SOMETHING WONDERFUL. *THEIR HERITAGE.*

Arcadia Publishing is the leading local history publisher in the United States. With more than 4,000 titles in print and hundreds of new titles released every year, Arcadia has extensive specialized experience chronicling the history of communities and celebrating America's hidden stories, bringing to life the people, places, and events from the past. To discover the history of other communities across the nation, please visit:

www.arcadiapublishing.com

Customized search tools allow you to find regional history books about the town where you grew up, the cities where your friends and family live, the town where your parents met, or even that retirement spot you've been dreaming about.